PRINTED & LA
Handkerchiefs

INTERPRETING A POPULAR 20TH-CENTURY COLLECTIBLE

BETTY WILSON

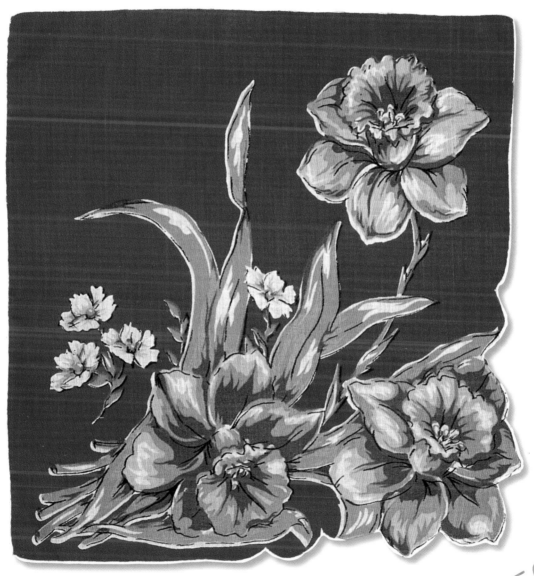

Schiffer®
Publishing Ltd

4880 Lower Valley Road, Atglen, PA 19310 USA

Published by Schiffer Publishing Ltd.
4880 Lower Valley Road
Atglen, PA 19310
Phone: (610) 593-1777; Fax: (610) 593-2002
E-mail: Schifferbk@aol.com
Please visit our web site catalog at **www.schifferbooks.com**
We are always looking for people to write books on new and related subjects. If you
have an idea for a book, please contact us at the above address.

This book may be purchased from the publisher.
Include $3.95 for shipping. Please try your bookstore first.
You may write for a free catalog.

In Europe, Schiffer books are distributed by
Bushwood Books
6 Marksbury Ave. Kew Gardens
Surrey TW9 4JF England
Phone: 44 (0)20 8392-8585; Fax: 44 (0)20 8392-9876
E-mail: Bushwd@aol.com
Free postage in the UK. Europe: air mail at cost.
Please try your bookstore first.

Copyright © 2003 by Betty Wilson
Library of Congress Catalog Control Number: 2003103330

Cover and book designed by Bruce Waters
Type set in Cooperplate Gothic, heads/ Zurich BT, text font.

ISBN: 0-7643-1801-2
Printed in China
1 2 3 4

Dedication

To Vance, my favorite bad habit, from his favorite waste of time.

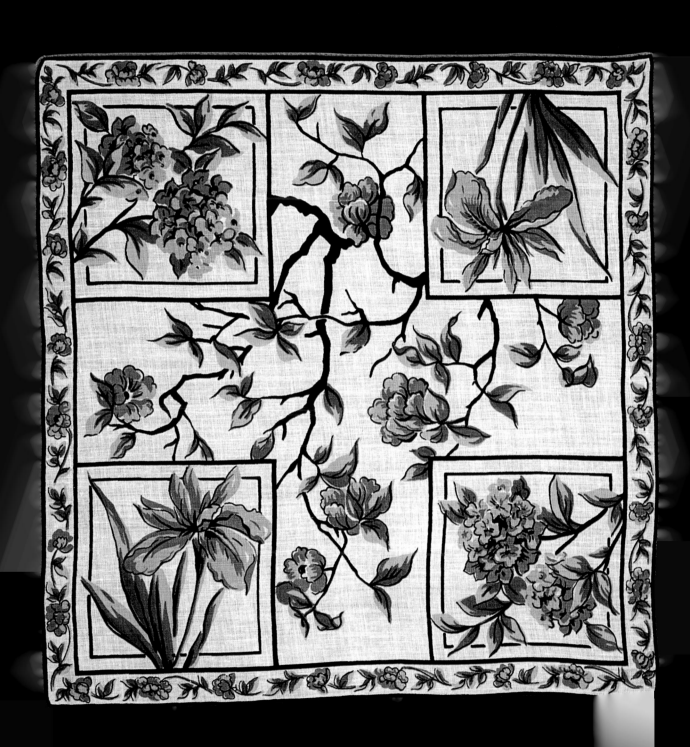

ACKNOWLEDGMENTS

Thank you, Nancy Schiffer, for the professional editing and good cheer throughout this book production. I feel privileged you found my research entertaining and of value to collectors. I also would like to give my warmhearted thanks to my mentors. Linda Rutschow inspired me too expand my hankie collection and generously contributed over twenty hankies shown in this book. Carol Joles is a generous friend who provided hankies, food, shelter, shopping companionship, advice, much laughter, and an incredible positive approach to life. Stacey Pawlak bestowed creative concepts and superior hand quilting on my favorite hankie projects. Darlene Campbell is a talented home decorator, when not teaching Chemistry, who creates outstanding hankie wall quilts. Judy Florence encouraged me to publish this book and shared her library of vintage catalogs. And continual thanks go to all the wonderful Eau Claire quilt group friends who didn't laugh too loudly at my bumpy quilt stitches and obsession with vintage hankies.

Thanks also to the Wisconsin business owners who allowed me to research in their shops: Virginia Holte at Osseo General Store in Osseo; Jessica Waite at Rustic Elegance in Cornell; David Craine at Craine's Antiques in Chippewa Falls, Hugh Passow and my friend Linda at Main Street Gallery in Eau Claire; Jim and Lisa Dutcher at Tip-Top Atomic Shop in Milwaukee; and Ann Cradler at Old Mills Market in Lake Mills.

To all my cyberspace quilting and vintage fabric friends, I greatly appreciated your around-the-clock accessibility, humor, and research support. One last, but not least, thank-you goes to Joan Kiplinger who provided outstanding fabric information and mentorship.

Photographs are by Betty Wilson. The items and products in this book may be covered by various copyrights, trademarks, and logotypes. All rights are reserved by their respective owners.

The products pictured in this book are from the collections of the author and various private collectors. This book is not sponsored, endorsed, or otherwise affiliated with any of the companies whose products are represented herein. This book is derived from the author's independent research.

PREFACE

There is nothing more delightful,
on a dreary winter day,
than to bring out your hankie collection,
and sort them every which way!

I started collecting vintage hankies after I moved to the Midwest. I had not seen or thought about hankies for at least 30 years, and was pleasantly surprised to see a pretty floral printed hankie at a thrift sale. Someone else purchased it while I dreamily stared off remembering how I used to give hankies as a gift to my favorite grade school teachers. As I looked at the empty spot on the table where the hankie had been, I felt like someone had just stolen my seat on the teeter-totter. Then I made a mental note to myself: be sure to procure future hankie finds into my possession before taking trips down memory lane.

It was an enlightening experience for this Western treasure hunter to be exposed to the Midwest's world of estate auctions, antique stores, and thrift stores. I saw thousands of items that had been purchased by someone's great-grandmother and then handed down, items that had been forgotten, packed away in attics for decades; items that were passed around and used by generations of people. These places became my hankie happy hunting grounds.

My growing hankie collection inspired me to investigate the "inside story" on hankies. I had burning questions:

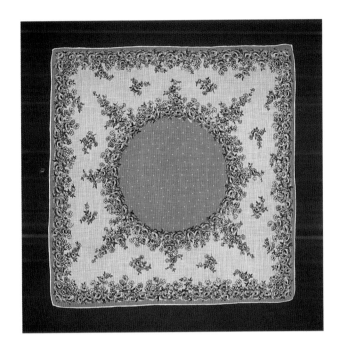

When and where were hankies first offered
 for sale?
What kinds of fabric are they made from?
Where can I find more?
How can I display my little treasures?
What hankie "care & feeding" directions
 could I find?

Perhaps Sherlock Holmes could immediately tell you the origin, time period, and thread count of any hankie given to him as a clue to a mystery, but the rest of us could use a few tips. This book was written especially for that purpose. Many of my own hankies patiently posed for their pictures and serve as visual examples throughout this book. Now I would like to share my hankie treasure trove of research with you.

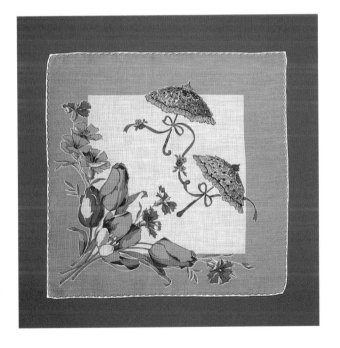

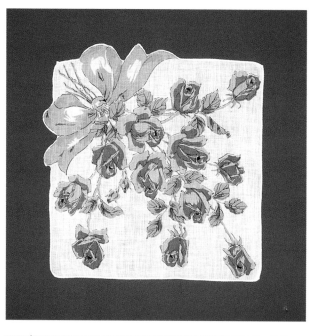
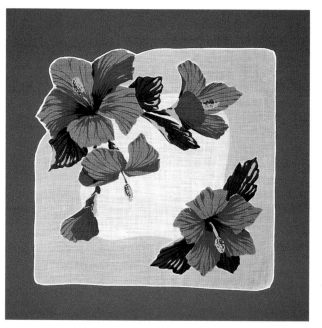
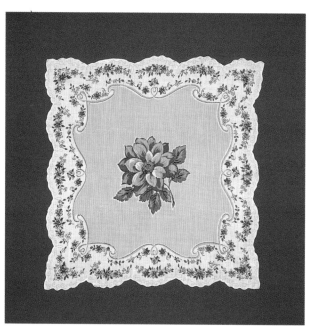
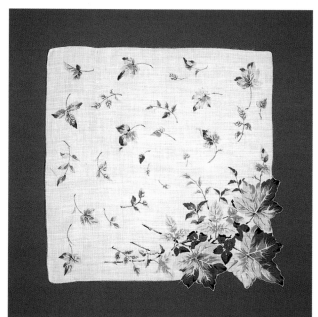
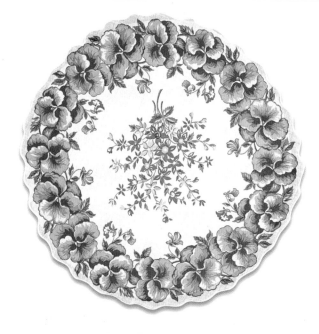

CONTENTS

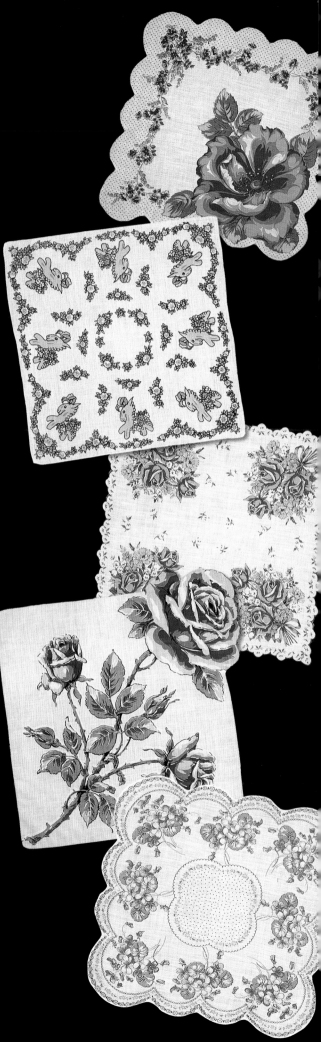

1900 TO 1919

EARLY 20TH CENTURY IMPRESSIONS

Hankies were a standard fashion accessory for gentlemen and ladies at the beginning of the 20th century. Every purse and suit had a hankie in residence. Hankies were always present at social occasions that might require their use by a lady to subtly signal a gentleman, dab away a tear of joy or sorrow, or shield a sneeze. From plain white to fancy laces, hankies were used to show signs of affection, give nurturing, and aid hygiene.

The decorative hankies of the day were made using fabric manipulation techniques to create floral and geometric motifs. A plain piece of woven linen fabric would be transformed using methods of drawn work, needlework, punched work, cutwork and appliqué. Other fabric types were also used, but the tightly woven linen hankies would maintain the best strength and provide a crisp and distinctive surface over the years.

I began my research on these little pieces of fabric with the *Sears and Roebuck* 1900 Fall catalog. To my surprise, it did not offer ladies handkerchiefs at all. It did show a lovely assortment of dresser boxes for handkerchiefs and gloves, proving that the hankie did have an honored place in a well-dressed person's wardrobe.

Next, I found a reprint of the *Sears, Roebuck* 1908 catalog. The catalog index looked very promising. It listed Ladies Handkerchiefs on pages 1012 and 1013. I quickly looked through the reprint only to

discover these pages were not present. Apparently, the original catalog the publisher reproduced had these particular pages missing. Still, the reprint provided a page of useful pictures of Drawn work, Renaissance, and fancy Spachtel linens. The name Spachtel is no longer used as a textile term. Today, we refer to this decoration technique as Irish Point, which is distinguished by open embroidery and cut work. Due to their small sizes and lightweight fabrics, these linens could be mistaken for vintage hankies today.

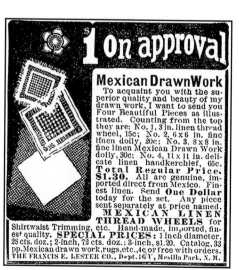

White and ecru hankies were the prevalent hankie colors as promoted in this Mexican Drawn Work advertisement from a 1904 *Farm Life Magazine*. Drawn work hankies were produced in the USA, Mexico, China, and Japan.

Dress fashions of the early 20th century con- tinued to be much the same as they were at the end of the 19th century. American wardrobes ech- oed England's. The 1909 *Ladies' Home Journal* had a romantic illustration showing the fashion of the day with ladies waving their hankies to honor a visiting dignitary.

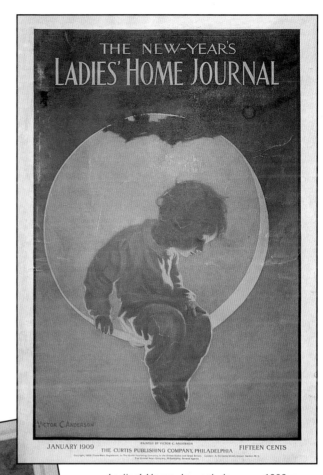

Ladies' Home Journal, January, 1909 cover.

"The Radiant, Young Wilhelmina Waving Her Hand in Bright Greeting to Queen Victoria." Illustration by Lucien Davis, R. I.,1909.

TRASH OR TREASURE?

Some people would have thrown this hankie away because it was found very worn, fragile, and smelling a bit musty. It is a wonderful silk 20th century hankie from the Alaska Yukon Pacific Exposition of 1909. Alaska was a Territory at that time. This commemorative hankie has a woven image that glistens when the light hits it just right and displays "*Manufacturers, Liberal Arts & Varied Industries Building*" text woven right into the cloth.

The treasure hunting story behind this find is not uncommon. I was antiquing in La Crosse, Wisconsin, and a small antique furniture store was an impromptu last-minute stop. I walked through the tightly packed store admiring the vintage furniture collected from local residences and saw a large straw basket filled with scarves and hankies! The store owner said he occasionally found them left inside furniture he purchased. His wife thought they were pretty so they collected them in a big basket and sold them for $1.00 each. I think this couple deserves a medal of honor for being such wise textile conservationists.

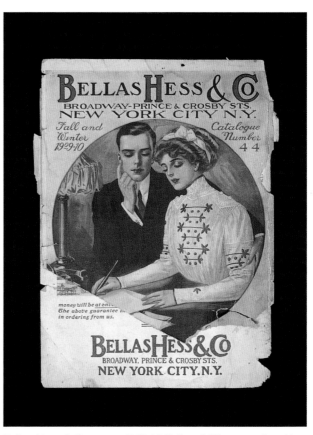

Bellas Hess & Company 1909-10 Fall and Winter catalog, No. 44, cover.

This silk hankie is in poor condition. *"ALEX"* is nicely machine stitched onto the corner. Perhaps a person could have their name sewn onto their hankie when they purchased it at the Exposition. Value $25-35.

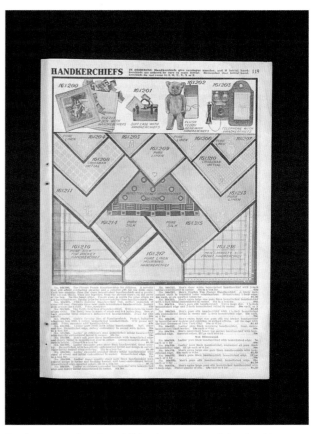

Catalog page showing children's toys containing hankies, hand embroidered initials selection, and mourning handkerchiefs.

The *Bellas Hess & Company* Fall and Winter 1909-10 catalog contained many pictorial hankie specimens. I found it humorous that the catalog copywriter did not feel it was necessary to reveal actual product measurements. There were no references to sizes for the ladies hankies. The gentlemen's handkerchiefs used mysterious code words like "top pocket handkerchief," "extra large handkerchief," and "men's extra large top pocket handkerchief."

Another intriguing, catalog-operating procedure was the system of paying for your mail-order hankies. These days we can use a credit card, send a check, or use some cyber payment method. To pay for your mail order the catalog suggested sending a post office money order, express money order, bank draft on New York, cash, or stamps. Stamps? Yes, United States postage stamps! They also informed the shopper that they do not accept revenue stamps, foreign stamps, due stamps, or stamps that are all stuck together. Sounds reasonable to me.

Small presents for children were popular items in the 1900s. There were delightful children's toys, which also contained white hemstitched linen hankies. These cute items were just the sort of thing to bring smiles to little nieces, nephews, and grandchildren. The next inevitable step was little hankie toys that were played with; the hankies were dispersed and the toy was eventually demoted to a toy box or shelf, or left under the porch. It would be easy to overlook one of these unapparent hankie toys if you never saw this catalog picture. Any of these cute toys would be a treasured addition to a hankie collection today.

Simple and stately initialed handkerchiefs for men and women were standard accessories. *Bellas Hess & Company* offered initial hankies, but made it very clear to the purchaser the letters I, O, U, V, X, or Z were absolutely not offered. Ladies would purchase hankies with their first name initial while gentlemen preferred their last name initial. Samples of this era's initial handkerchiefs are rarely found, because they were heavily employed and became unattractive.

Bellas Hess & Company offered a "mourning hankie," available at fifteen cents each or six for eighty five cents. These hankies were part of a grieving lady's daily accessories. Never elegant or elaborate, a mourning hankie was a plain white linen center cloth with a demure thin black edging of either black hemstitching, small black lace, or a thin black band of embroidery. Mourning hankies were a cultural icon from 1861, when Queen Victoria's husband, Prince Albert, died from Typhoid fever, until she died in 1910. (By the way, they had nine children together.) In the United States, the passing of the Civil War widows dramatically influenced the demise of mourning hankies' popularity.

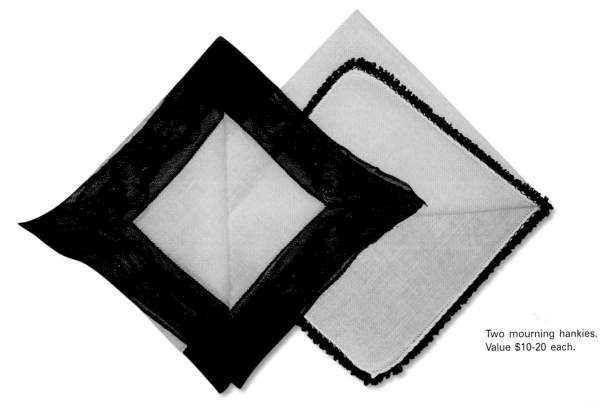

Two mourning hankies.
Value $10-20 each.

NEW DECORATIVE INTRODUCTIONS

At home and away, the white-on-white hankie was always carried to serve a lady's needs. Slipped in a pocket, up a sleeve, or inside a satchel, white hankies were ever present. There were linen crossbar dimity hankies, which had a woven grid pattern in the fabric, sheer white Swiss hankies with floral designs embroidered on each corner, and hankies of the finest sheer lawn fabric with embroidered edges. An entirely new design was the allover embroidered hankie, with wide areas of the borders decorated with miniature dots arranged in a variety of exquisite patterns.

Elaborate handmade hankies, imported from overseas, provided an ethereal visual delight. Two other new decoration techniques shown in the 1909-10 *Bellas Hess & Company* catalog were Irish Princess lace and English eyelet. Princess lace is a close relative of Battenburg lace, and English eyelet was previously used only to decorate larger linens. White hankies from Ireland, Switzerland, and France offered scalloped edges and lace.
Each fine hankie has the potential to become a family keepsake. I find the lace hankie with fabric insets so individually compelling. I cannot remember ever seeing two alike.

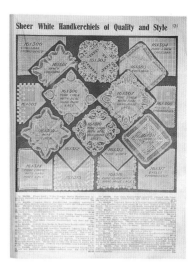

Bellas Hess & Company catalog pages showing hankies.

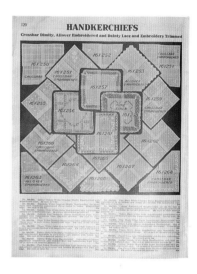

1900s drawn work hankie with lovely lace trim. Value $40-50.

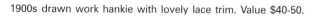

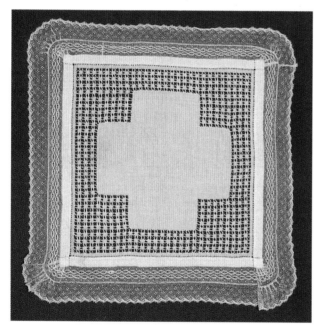

1900s hankies like those appearing on the catalog pages. Value $25-35 each.

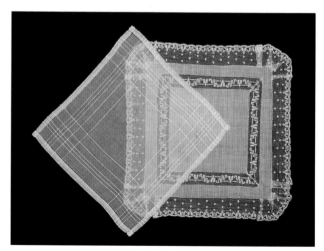

HOME HANDWORK

Thread manufacturers promoted their products by printing booklets with crochet and tatting samples for decorating everyday linens. You could own *The 1916 Nufashond Rick Rack Book* for a mere dime. Its Foreword reads:

We feel quite sure that the keenest pleasure to the needle worker will come from the thought that a hint contained in this little book enabled her to create a design of her own.

I enjoyed their gentle note of encouragement for beginners and inspirational suggestion to experienced needle workers. I can almost hear Ms. Manners saying it.

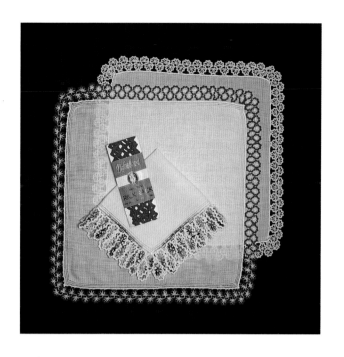

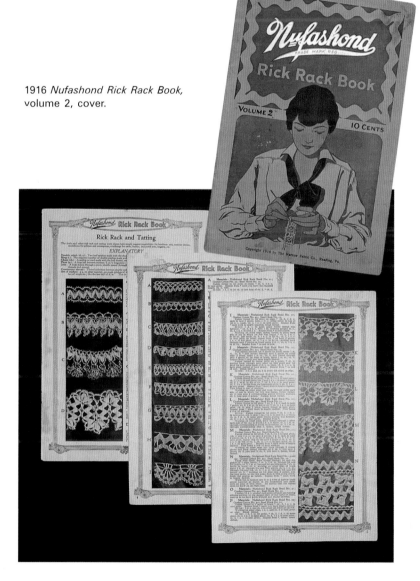

1916 *Nufashond Rick Rack Book,* volume 2, cover.

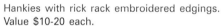

Hankies with rick rack embroidered edgings. Value $10-20 each.

WORLD WAR I COMMEMORATIVES

Military events were some of the first to be commemorated on American hankies. April 6, 1917, the United States declared war on Germany. American soldiers separated from home would send postcards and letters with little gifts (handkerchiefs) enclosed. It was a happy day when a lady received one of these, for it provided much needed comfort.

World War One "Theochrome" series 1235, military post card.

THROUGH THE TREES THE SUN IS SHINING
ON THE PEACEFUL SUMMER'S LANE.
AND THE BIRDS ARE SWEETLY SINGING
ON THE PATH BESIDE THE STREAM.

World War One silk hankie with printed image, hand coloring, embroidered slogan, and lace trim. Value $35-45.

World War One military fighting man printed in dark blue ink on silk with red and blue woven border accents. Value $25-35.

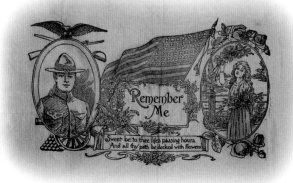

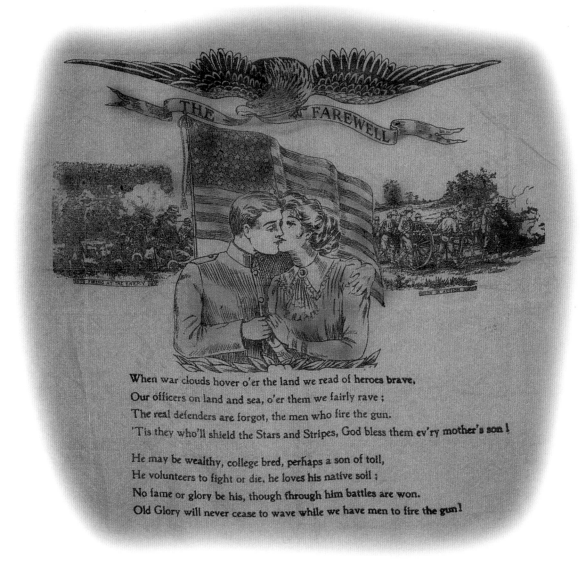

When war clouds hover o'er the land we read of heroes brave,
Our officers on land and sea, o'er them we fairly rave ;
The real defenders are forgot, the men who fire the gun.
'Tis they who'll shield the Stars and Stripes, God bless them ev'ry mother's son !

He may be wealthy, college bred, perhaps a son of toil,
He volunteers to fight or die, he loves his native soil ;
No fame or glory be his, though through him battles are won.
Old Glory will never cease to wave while we have men to fire the gun!

World War One *"Remember Me"* military silk hankie. This hankie has just one red ink color hand applied. Perhaps there were more and they faded. Value $25-35.

Recycled art! *Threads of History*, a book on handkerchiefs by H.R. Collins, shows a hankie with the same art work with a red, white, and blue striped border with small stars printed on the corners. This example of *"The Farewell"* military silk hankie has wonderful blue, red, and gold colored inks hand applied onto the dark blue imprint and a plain colored silk border trim. Value $25-35.

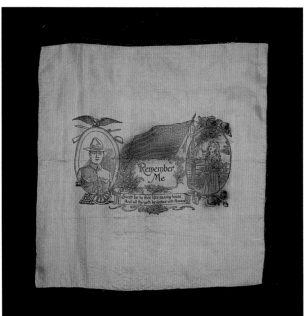

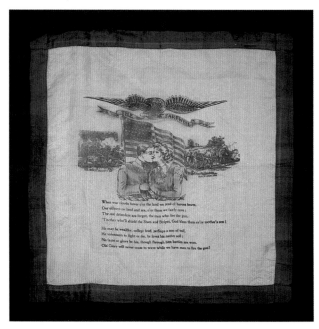

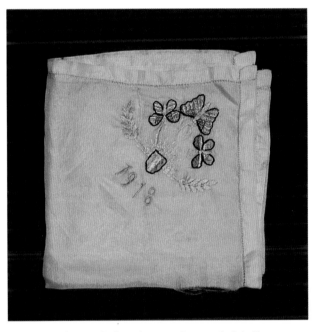

Elaborate World War One period military hankie holder. Value $45-55.

IN LIKE A LAMB AND OUT LIKE A LION

Speaking of things best left alone, politics were alive and active at the end of the decade. In America, the federal Volstead Act of 1919 prohibited the *sale* of alcohol, but it was still legal to *drink* alcohol. This and other social dichotomies led people to dress, socialize, and purchase in new directions. Department stores and mail-order catalogs positioned themselves to offer a wide selection of merchandise, and the economy was expected to greatly improve.

Military images with slogans, dates, dedications, maps, and European city names could be found decorating these small silk gifts. Most of the embroidered hankies were made to celebrate 1918, when the war ended. Some hankies were sewn into beautiful hankie holders, complete with flags and patriotic trim. Hankies with lace trim and hand embroidery work were also very popular.

Some military hankies survived better than others. I would like to save every one. I have made mistakes by washing some old hankies that I thought looked too scruffy. An example is the incredible 1918 embroidered butterfly hankie. I delicately hand washed it and watched as the non-permanent red dye spread across the silk like wild fire. It is now clean and boring and I am glad I have this pre-washed photo to share with you. Sometimes it is best to leave old hankies as you find them, especially silk ones.

Here are before and after pictures of a wonderful silk embroidered World War One period hankie. I thought it looked too scruffy, so I gently washed it. Oops! Value $1-5.

Patriotic embroidered World War One period silk hankies. In their current condition, the values are, from far left, $10-25, $35-45, and $20-35.

1920 TO 1929

CATALOGS AND MAGAZINES

The 1920s was a time to bid farewell to Victorian and Edwardian values. Young adults embraced new, energetic dances and wailing jazz tunes. The 19th Amendment to the U. S. Constitution was ratified and American women were granted the right to vote. Electricity became available, right inside the house, and electric motor sewing machines were introduced. Mass-production techniques offered a wider range of affordable products to the public. Consumerism was considered the key to emancipation and democracy, at least that is what the manufacturers and retailers were promoting.

This 1922 *Bellas Hess* catalog shows hankies. It and like catalogs help to identify and date hankies.

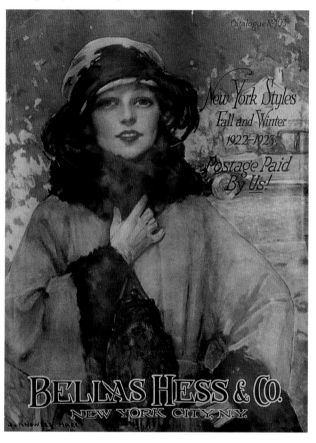

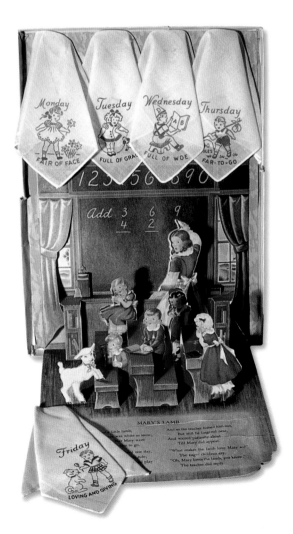

Two pretty hankies showing lovely embroidery work of the early era. Value $5-10 each.

The discovery, in 1922, of Tutankhamen's Tomb, near Thebes, prompted change in clothing fashions in Europe and America. The public became enchanted with Egyptian motifs and colors. "Tutmania" designs were used in a whole new range of textiles and Art Deco styles smoothly incorporated Egyptian motifs. The big players in textile fashion industry were in New York City and Chicago, and they were positioned to expand their markets to the rest of the country.

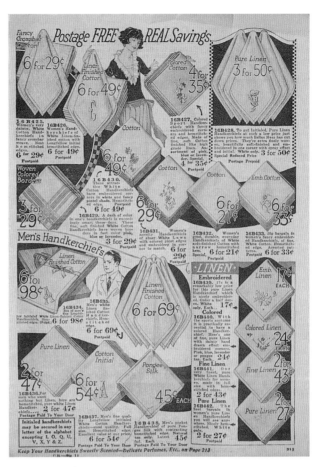

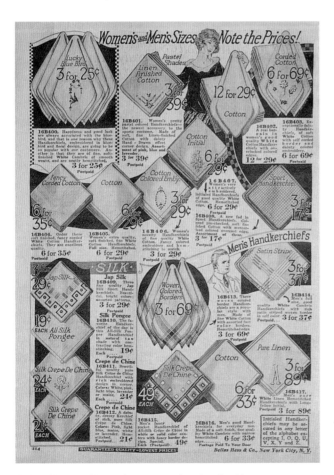

Bellas Hess 1922 catalog pages showing hankies.

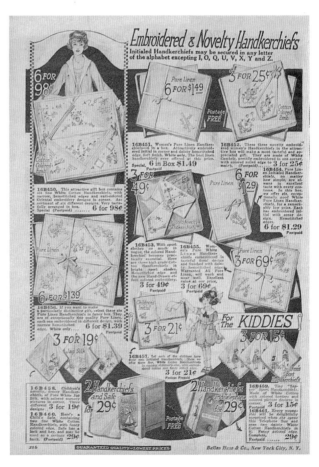

The 1923 *Woman's World* magazine offered ladies the opportunity to subscribe to free mail-order catalogs of the day. The appeal of seeing the latest fashions and shopping from your livingroom chair was irresistible.

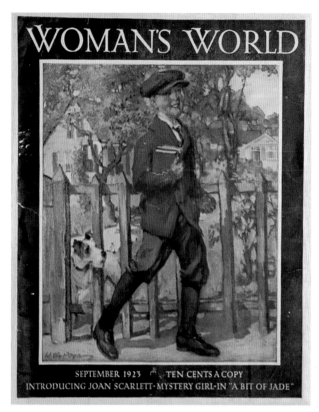

Woman's World 1923 magazine cover.

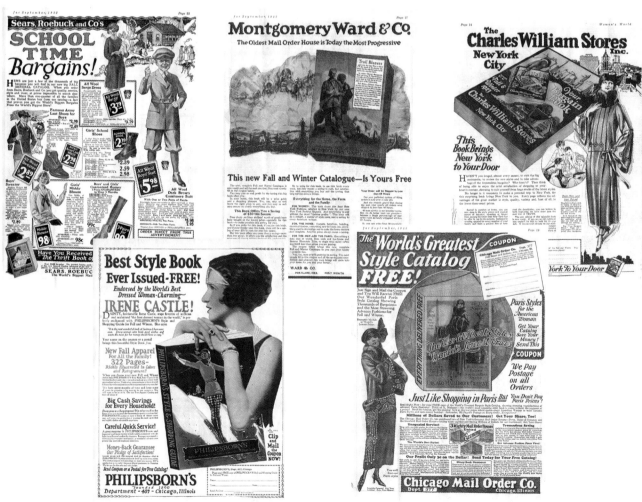

Five samples of full page advertisements offering *free* home shopping catalogs.

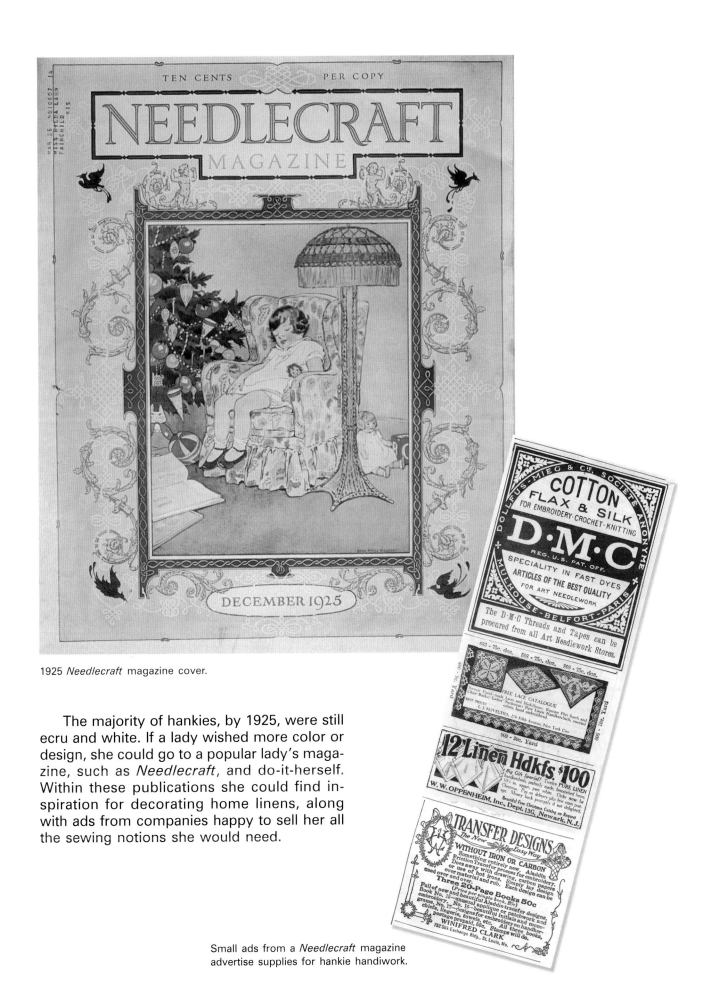

1925 *Needlecraft* magazine cover.

The majority of hankies, by 1925, were still ecru and white. If a lady wished more color or design, she could go to a popular lady's magazine, such as *Needlecraft*, and do-it-herself. Within these publications she could find inspiration for decorating home linens, along with ads from companies happy to sell her all the sewing notions she would need.

Small ads from a *Needlecraft* magazine advertise supplies for hankie handiwork.

The *Charles Williams Store's* 1927 catalog illustrates the atmosphere of comfort and prosperity. The 1920s was a wonderful time to be alive for lots of people. Commerce was active and the stock market made many feel wealthy and secure. The future looked very bright.

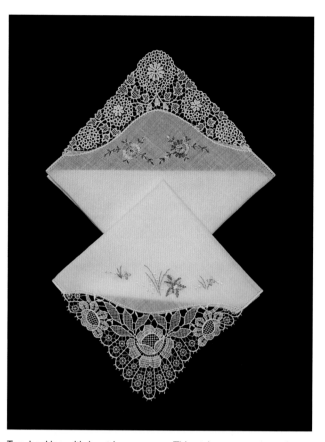

Two hankies with inset lace corners. This style was very popular and there were many different selections. Value $5-10 each.

Charles Williams Stores 1927 catalog cover.

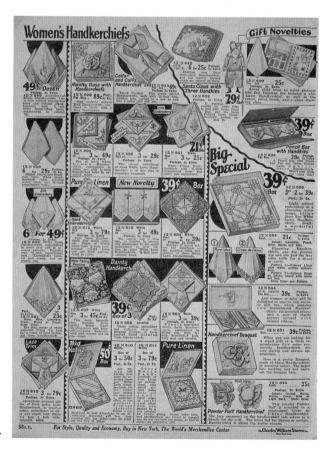

Charles Williams Stores catalog page with hankie pictures.

HANKIE BOXES

Color printing was added to hankie box decorations to promote sales. Today these boxes are collectible, even when found empty. *The National Importing Company Fall and Winter Supplement 1927-1928 Catalog* presented a great selection of boxed hankies. See if any look like something you might have. The original purchase price for these box sets ranged from 69 cents to $2.00 per box.

Cover of the 1927-28 *National Importing Company* catalog.

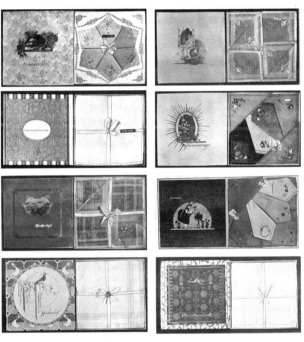

Hankie boxes from this catalog.

You can never be absolutely sure the hankies you find inside a hankie box are the original contents. I have found boxes with several layers of hankies, and some boxes are found completely empty. There are also loose sheets with hankies still pinned to them that you know must have been in a nice hankie box at one time. These boxes are not always in prime condition, but they can be found at auctions, thrift stores, and estate sales. If you collect hankies in boxes, remove any pins you find so the hankies do not become discolored from the deterioration of the metal. Never tape your hankies boxes back together; just enjoy their rustic condition.

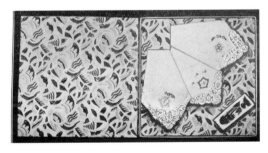

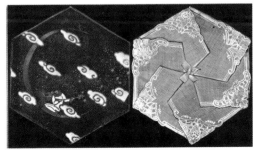

Triangular shaped hankie box with a single hankie inside. Value $15-20.

Art Deco canine decoration. Very nice set of embroidered hankies inside. Value $20-25.

This hankie box came with some great tags and pretty embroidered hankies. Value $15-20.

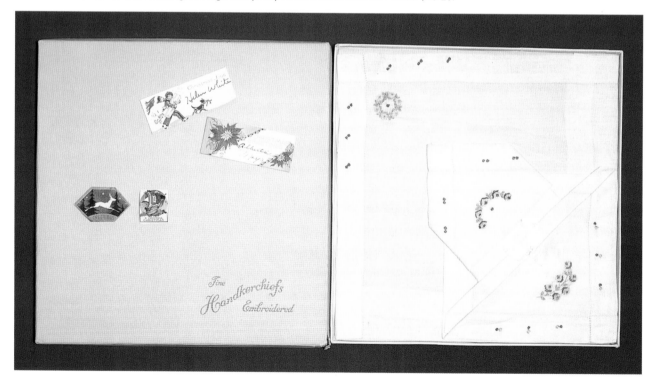

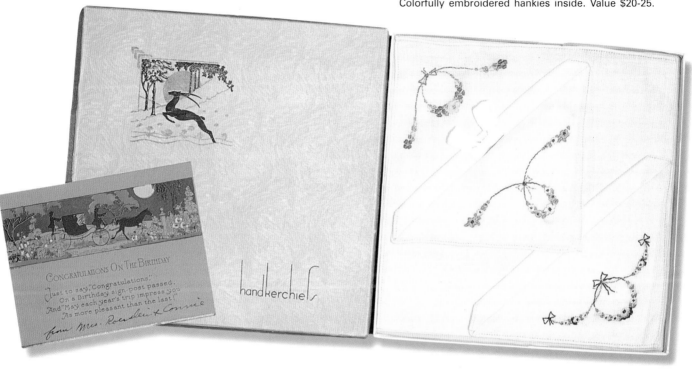

Art Deco stag with a Happy Birthday card included. Colorfully embroidered hankies inside. Value $20-25.

This box has a colorful lithograph accent. The hankies are tightly embroidered. Value $20-25.

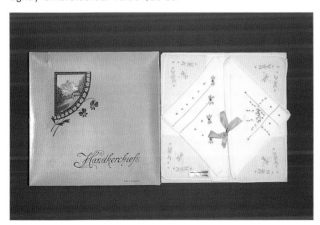

Box with seaside artwork. The hankies are loosely embroidered, but still very pretty. Value $20-25.

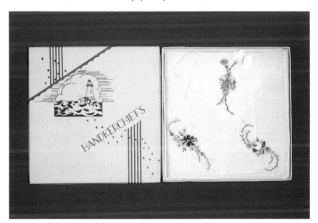

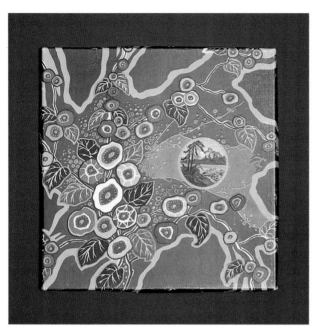

Exceptional lithographed hankie boxes. Value $10-20 each.

A Christmas gift from a collector's admiring husband! Wonderful children's hankie box with hankies glued to a three-dimensional foldout card. You can see it opened on the first page of this chapter. Value, priceless to me!

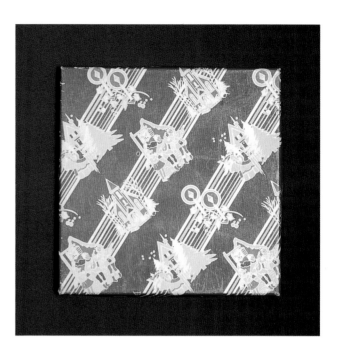

FALL OF THE STOCK MARKET

The 1920s, one of the most fashionable decades, dramatically ended with the stock market crash in October, 1929. People everywhere used their hankies extensively that day, and for many thereafter.

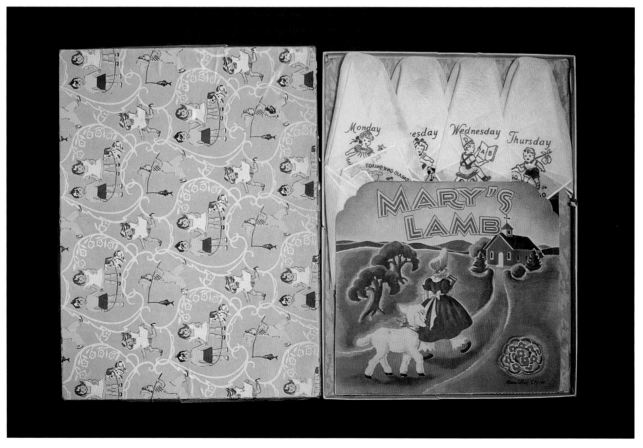

1930 TO 1939

The 1930s began with the Great Depression and, by 1932, there were fourteen million people out of work in America. The fashion industry responded by cutting their prices dramatically and producing less expensive items. Women varied the appearance of their existing wardrobes by using hankies as a fashion accessory. They could be tucked in a jacket pocket or folded into a floral shape and pinned to a blouse.

It is difficult, today, to find clothing catalogs from the 1930s because people practiced recycling extensively. They took a catalog to read while visiting the outhouse, and it never seemed to come back to the house.

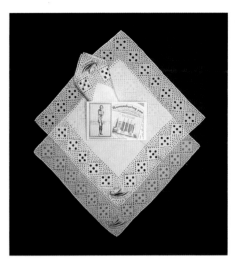

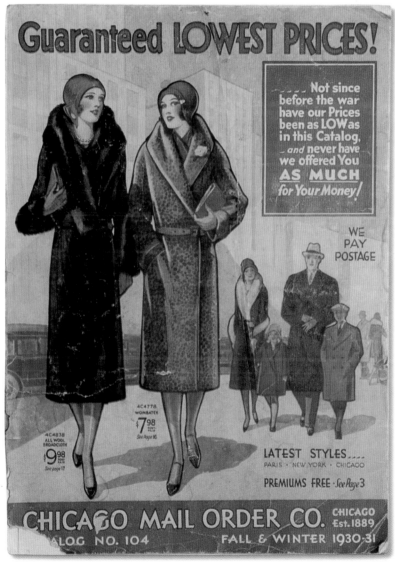

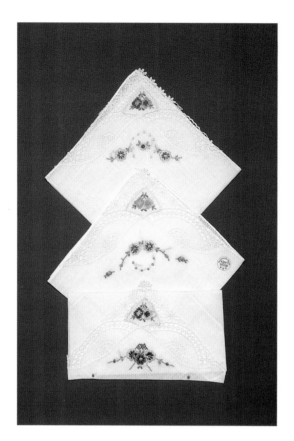

Lace trimmed hankies with additional embroidery work. Value $5-10 each.

1930-31 *Chicago Mail Order* catalog pages showing hankies.

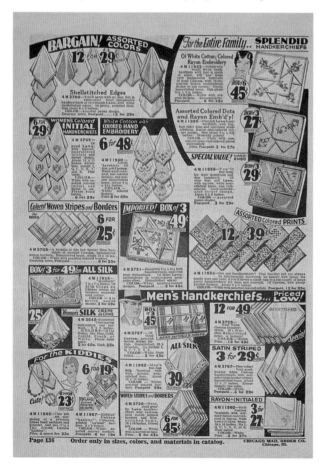

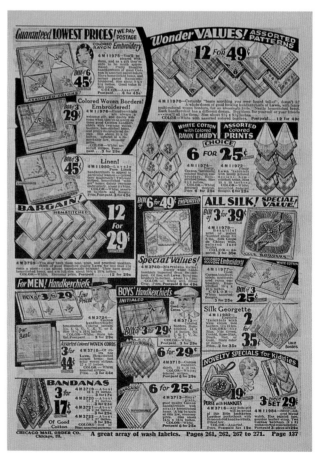

Business-to-Business Sales

Butler Brothers Dry Goods catalog for October, 1932, provided a large selection of goods directly to mail-order catalogs and department stores. Many of these styles of vintage hankies can be found in antique stores. The hankies have embroidered decorations, which typically are white. Some have colored threads woven into the fabric or subtle additions of colored embroidery.

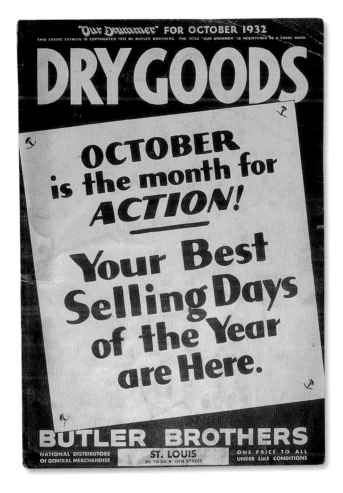

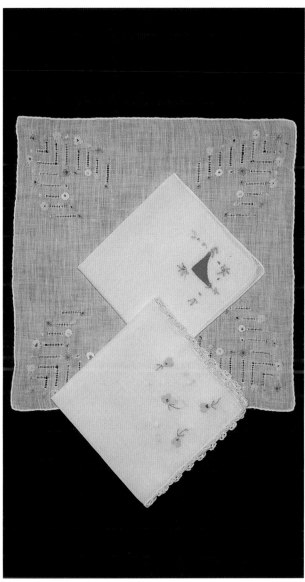

Appliquéd and embroidered hankies. Value $5-10 each.

Drawn work and embroidered hankies. Value $5-10 each.

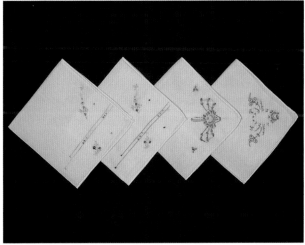

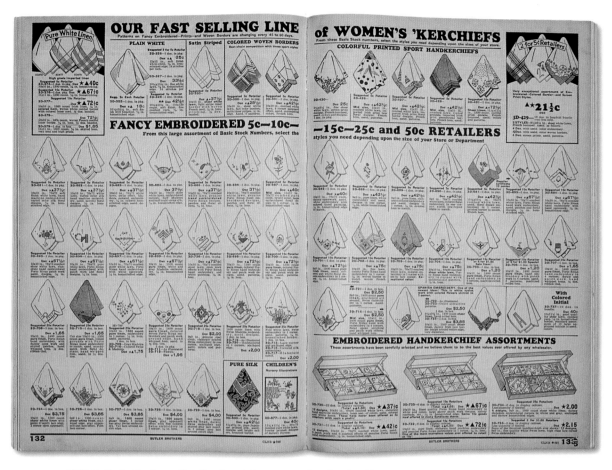

1932 *Butler's Brothers Dry Goods* catalog pages showing hankies.

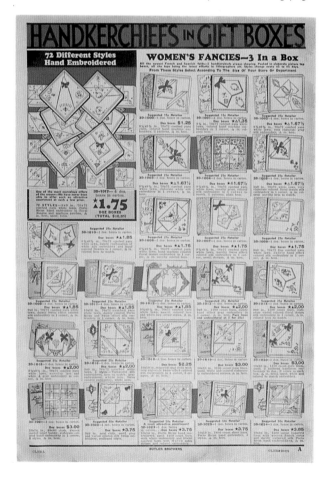

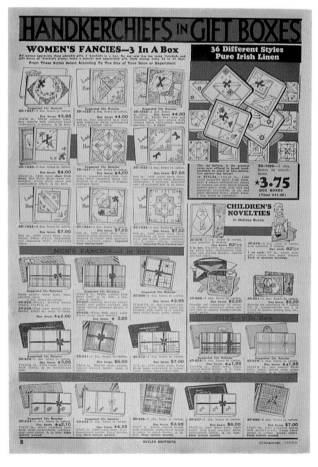

30

A Century of Progress

The postcard and silk hankies shown at the front of this chapter were sold as commemoratives during the 1933 Century of Progress International Exposition in Chicago, Illinois. Countries from around the world sent delegates to display new technologies and products with the aim of promoting international commerce. Japan presented their exquisite silk fabrics, which they titled "Queen of Fibers."

Thrifty Shoppers

Plenty of advertising space was given to promoting how smart and thrifty shoppers were who purchased from The *Chicago Mail Order* 45th Anniversary Catalog (1934). It offered a tiny hankie selection at extremely low prices. Hankies that were printed with two-tone chromatic designs on white backgrounds began to appear at that time.

1934-35 *Chicago Mail Order* catalog illustration.

Gorgeous Geometrics

The *Bellas Hess* 1937/38 catalog showed incredible geometric designs on hankies that stand out from traditional offerings. This type of hankie can be found infrequently, so they have become favorites to collectors. These designs were produced only for a short time, and the variety is astounding. Some are printed with exclusively geometric shapes while others combine floral icons with flowing shapes. A third type has realistic-looking flowers paired with rather odd geometric textures. Be sure to visit the Geometric Gallery, at the back of this book, to view additional colorful hankies.

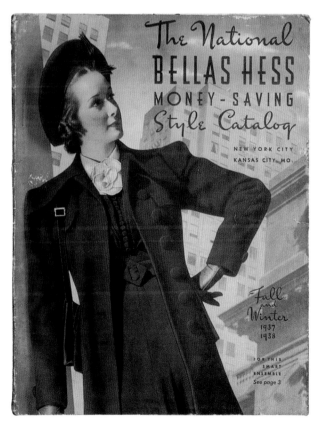

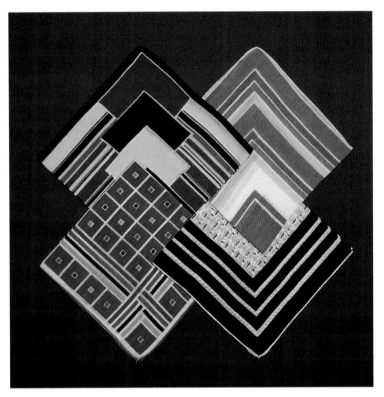

Geometric designs on hankies of the 1930s. Value $5-15 each.

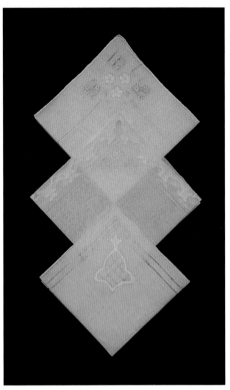

Also sighted in *Bellas Hess* catalog were embroidered and fabric appliqué hankies similar to these examples. Value $10-15 each.

1937-38 *Bellas Hess* catalog page showing many geometric design hankies.

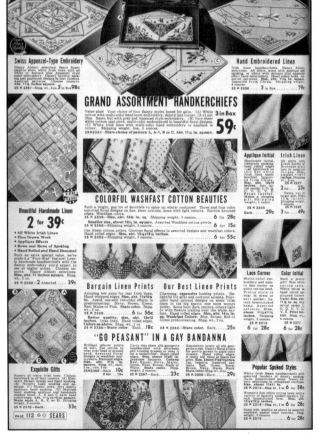

Catalog page showing an outstanding selection of geometric designed hankies.

STORE OFFERINGS

There are hankies styles that don't seem to appear in the catalogs but fit the design styles of the late 1930s and 1940s. These include cotton fabric with elementary images, some with stitched outlines, of plants and animals paired with monochromatic colors. This group of hankies is valued today $10 to 20 each.

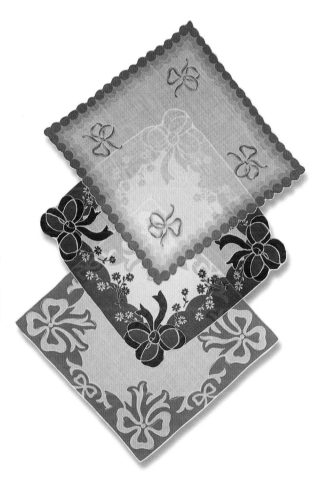

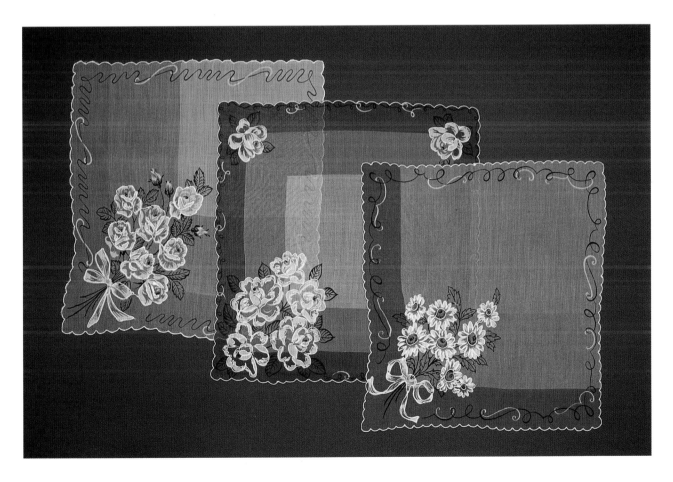

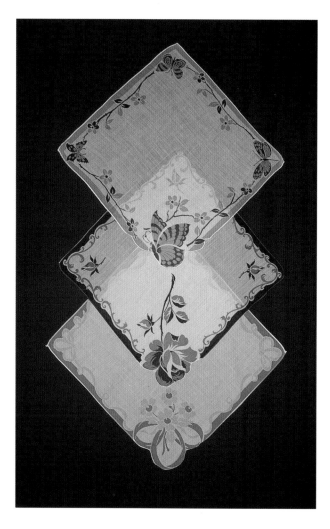

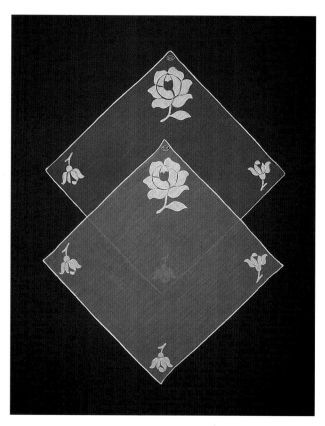

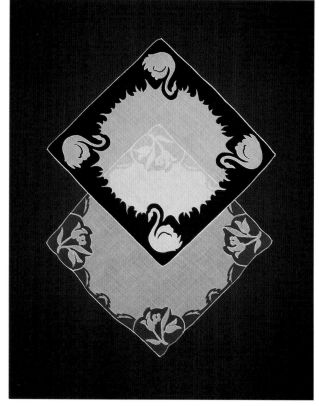

HANKIE PROMOTIONAL CAMPAIGNS

Vogue magazine was a favorite showplace for the promotion of hankies to thrifty shoppers. Burmel and Kimball handkerchief manufacturers targeted *Vogue* for aggressive national advertising campaigns. By appealing to many women's desire for beauty and their gathering instinct, several savvy campaigns were devised. Other manufactures followed their lead by offering special occasion hankie designs.

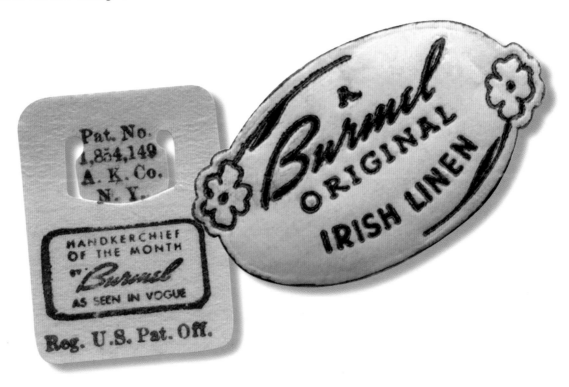

BURMEL'S HANDKERCHIEF OF THE MONTH

Vogue magazine's "Hankie of the Month" advertisements showed one lovely hankie and made sure you were able to find just the one you wanted by stocking several colors and variations at major department stores. The hankies' clever names made their purchase even more compelling.

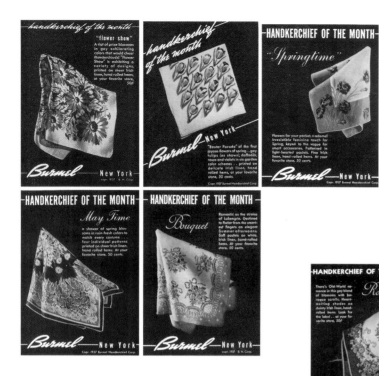

1937 *Vogue* magazine Burmel hankie promotional ads.

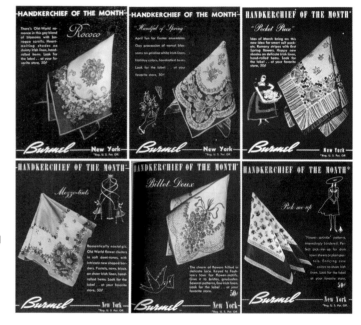

1938 *Vogue* magazine Burmel hankie promotional ads.

1939 *Vogue* magazine Burmel hankie promotional ad.

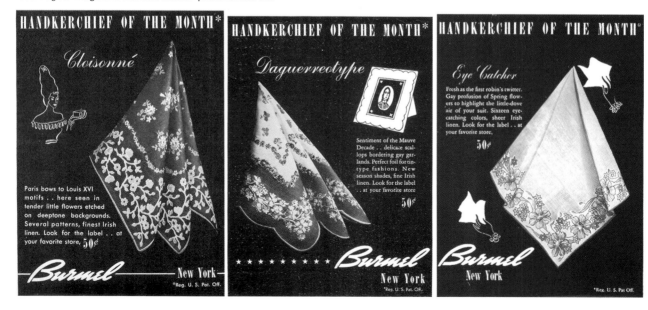

Burmel created a series of hankies illustrated with birds.
Value $10-20 each.

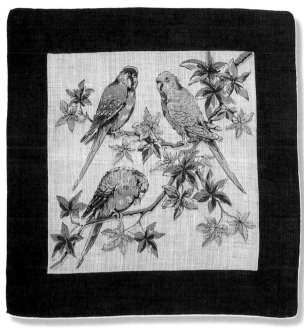

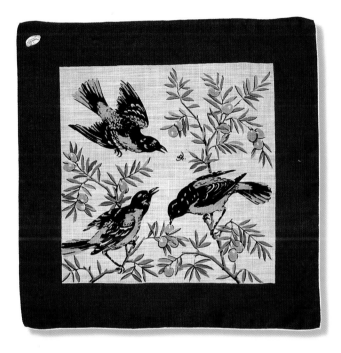

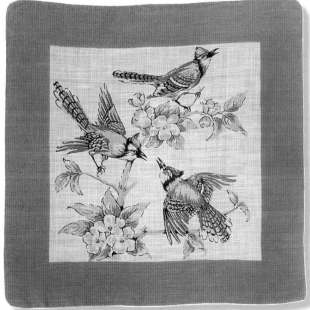

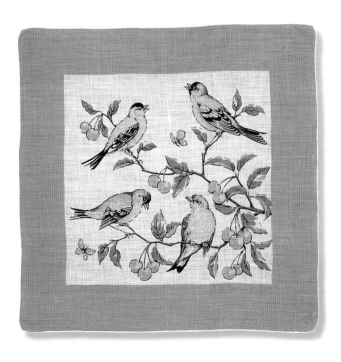

KIMBALL'S FLOWER OF THE MONTH

Kimball promoted retail sales for their hankies in *Vogue* magazine with ads the same size and style as Burmel's. Perhaps a bit of market spying took place between the two companies; their concurrently introduced campaigns were impressively similar. See if one of your hankies appears in these "Flower of the Month" offerings.

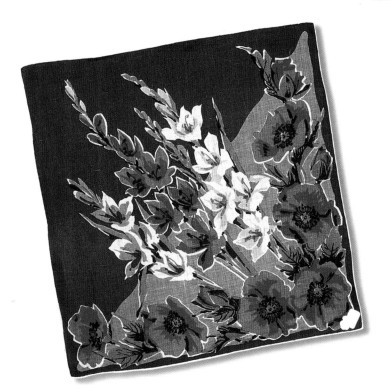

1938 *Vogue* magazine Kimball hankie promotional ads.

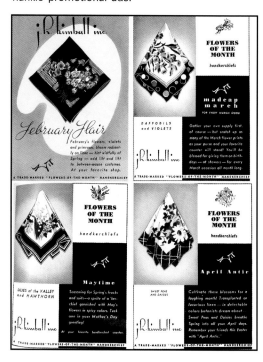

Best Seller

Infrequently one can find a hankie with a Best Seller label. These hankies range from pretty and utilitarian, as the one shown, to elegant.

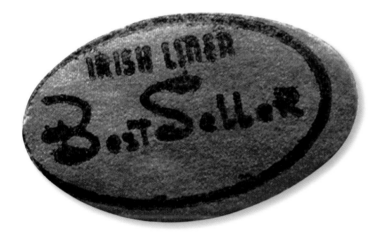

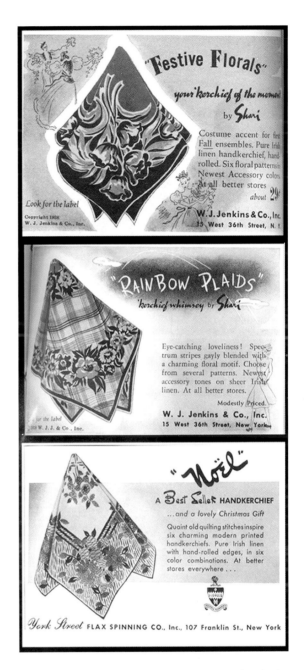

Several 1938 *Vogue* magazine hankie promotional ads for W. J. Jenkins & Company, Inc. designed by Shari. The Best Seller hankie ad by York Street, Flax Spinning Company was a very interesting find.

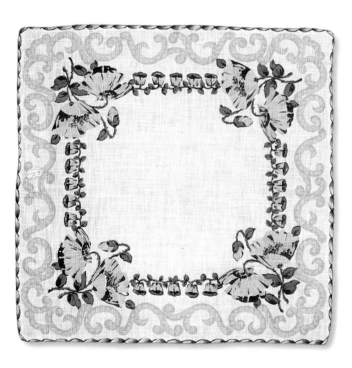

Best Seller hankie with label. Value $5-10.

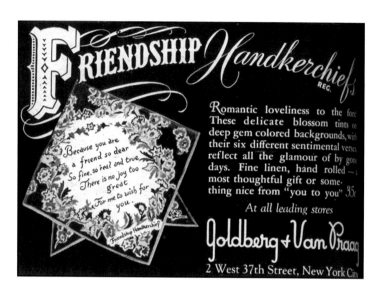

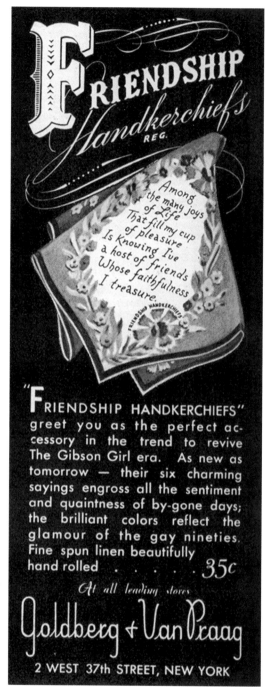

1938 *Vogue* magazine Friendship hankie promotional ads. Made by Goldbery and Van Praag. What a wonderful gift!

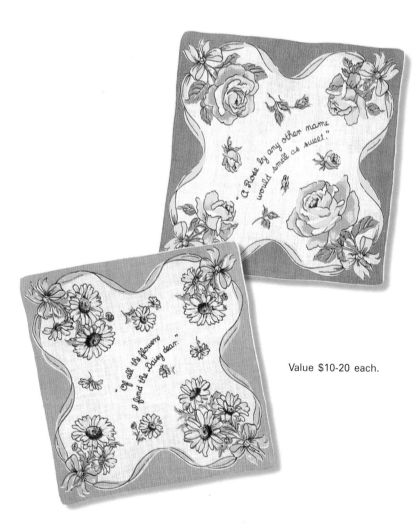

Value $10-20 each.

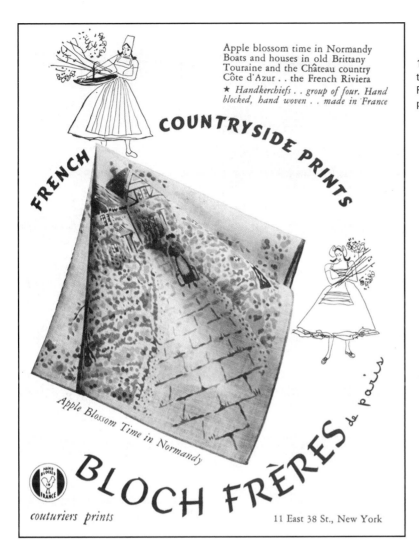

1938 *Vogue* magazine ad with an international flavor, New York, Normandy and France are each represented by this little piece of fabric.

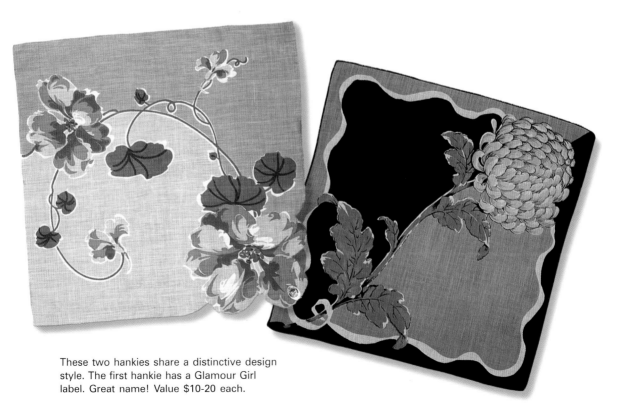

These two hankies share a distinctive design style. The first hankie has a Glamour Girl label. Great name! Value $10-20 each.

THE HANKIE INDUSTRY

The design, manufacture, and packaging of hankies was a substantial industry with factory workers and home piece workers during the 1930s. The 1939 Census of Manufacturers reported more than 96 percent of the hankies purchased in the United States were produced in New York, New Jersey, and California.

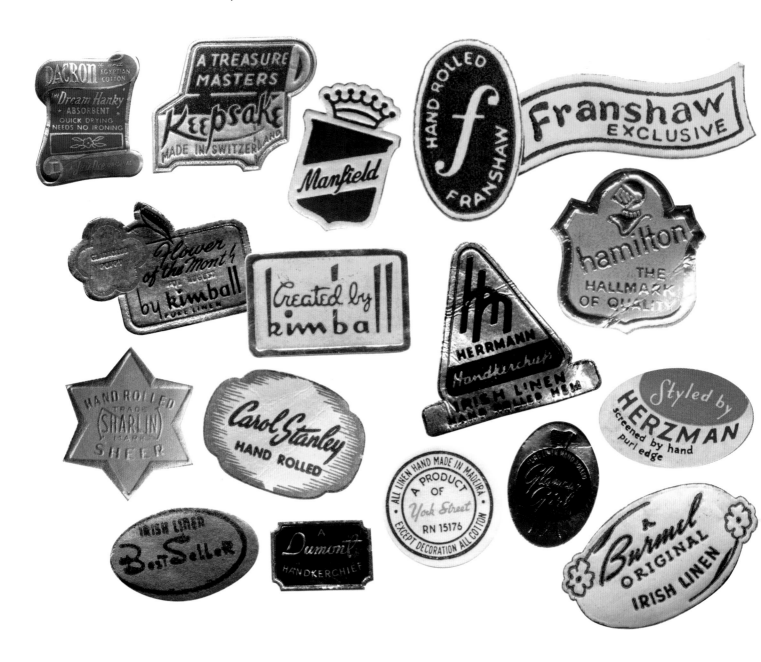

1940 TO 1949

REACTIVE MARKETING

Children everywhere enjoy participating in groups that promoted the development of healthy bodies and minds. Unfortunately, during the 1940s, the infectious Polio virus was a great concern for parents of young children. Germs had become a monster, as the "Homicide in a Handkerchief" advertisement illustrates. People concerned with cleanliness found the introduction of disposable tissues a sensible alternative to fabric hankies.

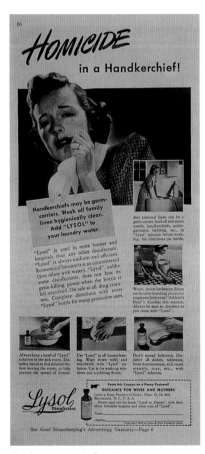

Ad from a 1940 *Good Housekeeping* magazine.

Boy Scouts of America handkerchief, circa early 1940s. Scout handkerchiefs are very rare. Neckerchiefs are worn as part of a Scout's official uniform. A neckerchief is large, like a bandana, and is not considered a handkerchief. Value $50-60.

WORLD WAR II

After Japanese bombers attacked Pearl Harbor, Hawaii, on December 7th 1941, the United States declared war on Japan. Forthwith, attention to the production of weapons and military equipment and clothing took precedent in America. Be sure to visit the Fabric Gallery at the back of this book to see some unusual fabrics used to make hankies due to material shortages. Imports of handkerchiefs from China, the Philippine Islands, the Madeira Islands, and some European countries were reduced, and then ceased, in 1942.

Women were recruited by the armed forces and production businesses to replace men who went into national service. Employment became opportunity for many housewives.

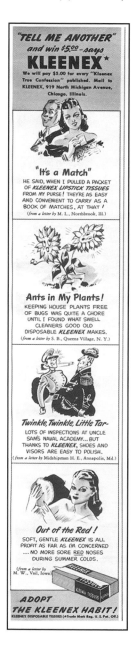

1941 *Look* magazine Kleenex ads were appealing to the public's pocketbook. The uses of patriotic themes to be thrifty and conservative were prominent in a variety of product ads.

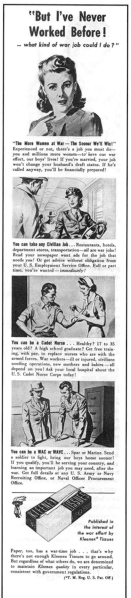

Kleenex supported the recruitment campaigns while collecting some good publicity along the way, as shown in this full column, 1944, *Look* magazine ad.

The soldiers who fought during World War II sent home tokens of affection. Military hankies were typically of colorful fabric with *"Sweetheart," "Mother,"* or *"Sister"* machine embroidered along with the logo or name of the military group.

Military hankies were available for purchase at the military base PX stores.

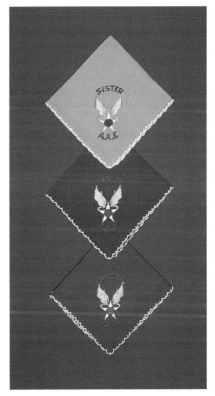

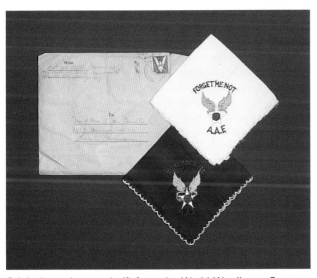

Original envelope and gift from the World War II era. *Courtesy of Walter A. Wolak.*

HARD TIMES

The United States' handkerchief industry, in 1942, employed factory workers and an estimated 2,145 home workers during peak seasons. The home workers were hand-rolling, monogramming lace, and cutting scallops for the factories, as well as setting and cutting corners, pressing, folding, pinning to cards, tying, and boxing. Sometimes the home workers provided hand embroidery, appliqué, drawn work, hem whipping, and hand painting. The turnover rate for home workers was high, and each worker was "tried out" before being retained.

The home workers were paid the 1942 minimum wage of 40 cents an hour, or they could be paid a predetermined amount for each piece they completed. Home workers were required to meet a minimum piece rate within a 40-hour time period. It was common for these workers to falsify their reports of hours worked because they were afraid of loosing their jobs. It was also common for the employer to have pay discrepancies concerning what they really paid home workers and what they reported paying them. This practice was discovered by U.S. Government Wage and Hour Division workers who inspected nine New York firms. Some home workers were paid less than 10 to 20 cents an hour, while the company payroll data reported paying as much as 56 to 89 cents an hour. The effect of this investigation was a dramatic cutback, and then curtailment, of using home workers.

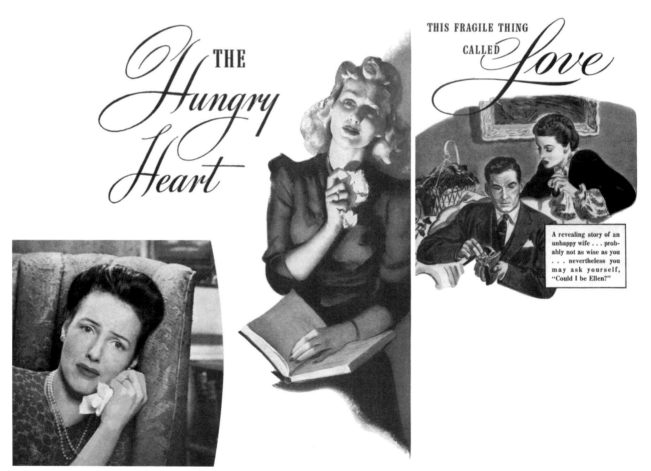

Story illustrations with hankies from various *Woman's Day,* 1940s, magazines. The presence of a hankie accentuates a woman's mystery and drama, with a bit of vulnerability thrown in.

The 1943 *Sears, Roebuck and Company* catalog had a small selection of cloth hankies representing one specimen from each decorative style. Other retail company catalogs, particularly *Montgomery Ward*, enjoyed brisk hankie sales and always seemed to have a better selection.

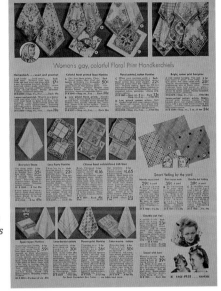

Hankie selections from a 1943 *Sears* catalog. Their main feature was durability rather than beauty.

Needlework hankies similar to those shown in the 1943 *Sears* catalog.

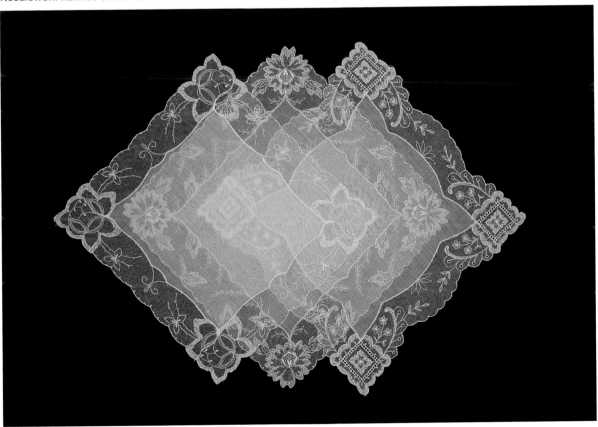

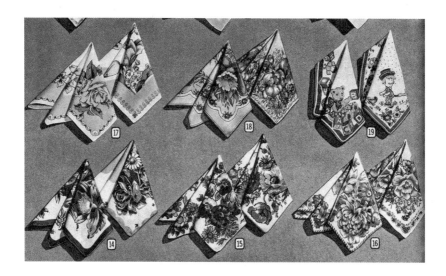

The 1944 *Montgomery Ward* catalog offered a varied selection of floral and children's hankies, particularly those in a square shape. A new item in their hankie collection was a greeting card with a hankie folded into the shape of a pretty flower. What a nice and inexpensive gift idea!

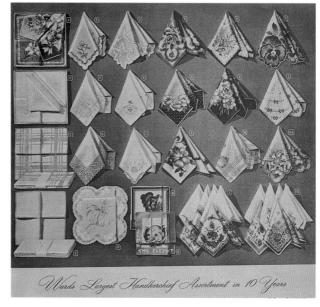

Hankies offered in the 1944 *Montgomery Ward* catalog.

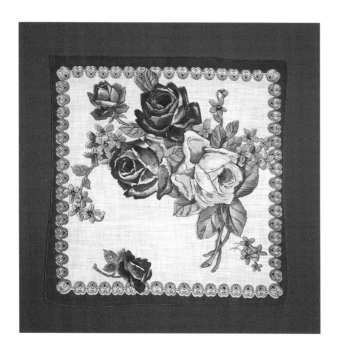

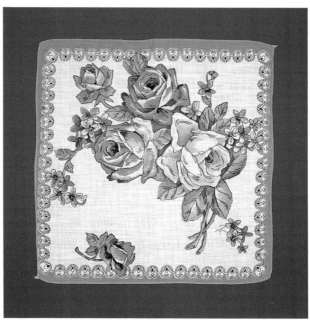

Hankies similar to the decoration styles offered by the 1944 *Montgomery Ward* catalog. Note the square shapes and identical designs that were silk screened in different color combinations. These were very pretty and functional hankies. Value $5-15 each.

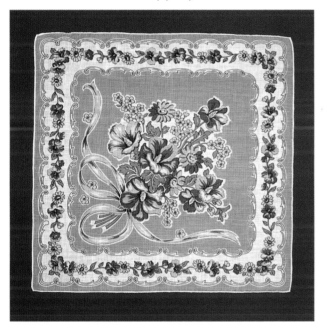
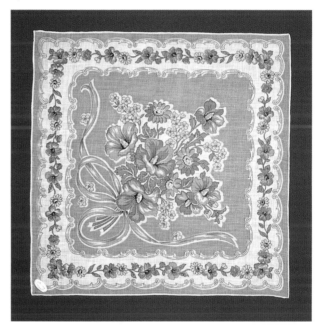
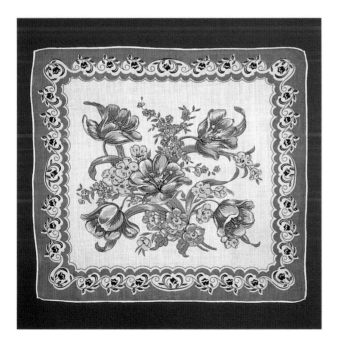
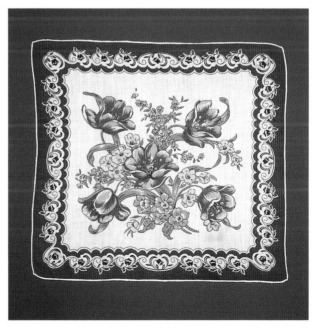

AFTER WORLD WAR II

After World War II ended in August of 1945, overseas military personnel looked forward to returning home; happy days were here again! A twinkle in many Americans' eyes led to a Baby Boom, as families grew and suburban communities blossomed.

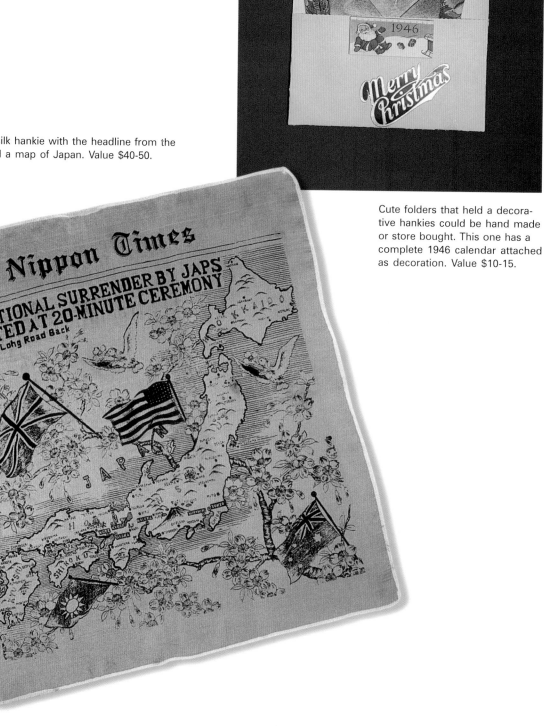

Commemorative silk hankie with the headline from the *Nippon Times* and a map of Japan. Value $40-50.

Cute folders that held a decorative hankies could be hand made or store bought. This one has a complete 1946 calendar attached as decoration. Value $10-15.

50

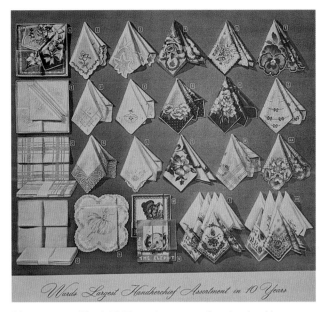

Montgomery Ward 1945 catalog page showing hankies.

Hankies with hand-rolled edges were usually preferred, but consumers gradually accepted machine hemmed ones as they were less expensive. The price of American labor rose to make it impossible to produce high quality hankies for the same price. *Montgomery Ward's* 1945 catalog hankie selections left a lot to be desired. Like most of the catalogs, they offered primarily square hankies, just very few with scalloped edges. The 1946 *National Bellas Hess* catalog had an extremely small hankie selection. Their cautious attitude turned out to be a big marketing mistake for the economic recovery was incredibly strong. Consumers, tired of being conservative, wanted to shop!

Major department stores of the day, such as Sears, Montgomery Ward, Gimbel Brothers, and Marshall Field, offered a large selection of hankies at their store locations, but did not represent them equally in their mail order catalogs. As more shoppers could drive to stores, instead of depending on mail order catalogs, many beautiful hankies were sold at the stores. Examples are shown in several sections of the Hankie Gallery in the back of this book.

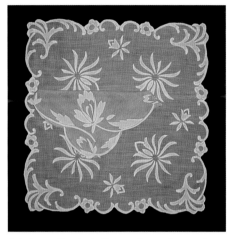

Fabric appliqué similar to those the catalog offered. Value $15-20 each.

Hankies by Tom Lamb. Value $15-20 each.

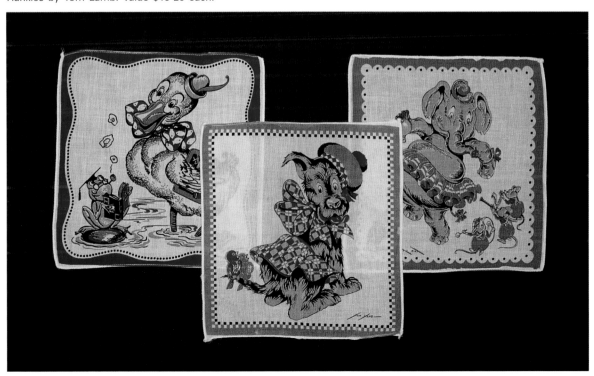

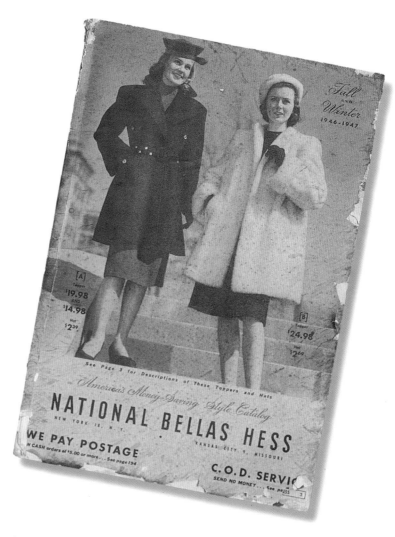

Hankies like those shown on the catalog pages. Value $5-10 each.

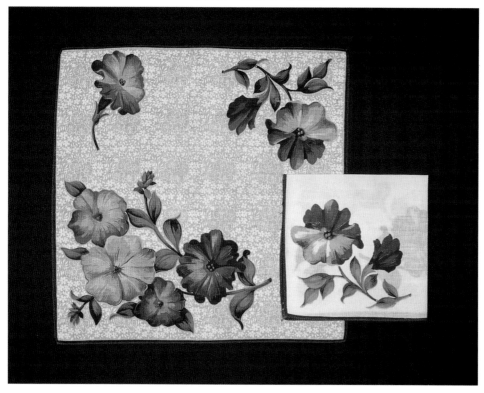

Hankibrellas

I decided to test my cyber-vintage-fabric friends with an historical question: Does anyone remember hankie umbrellas? Thank goodness Linda Learn was impressed by these and sent me this reply.

Did anyone else ever get the party favors that were made with a hankie? They were umbrellas. They started with a pencil covered with a spiral of ribbon. Then the hankie was centered over the eraser of the pencil and a pin was pressed through the hankie into the eraser to hold it. Then corners and the centers of the sides of the hankie were pinned to the ribbon on the pencil. Then paper circles, cut in half, were rolled into cones and fitted into the spaces between the pins so the umbrella shape was made. The edges of the hankie were folded up into the rolls of paper and the pin was taken out of the top of the pencil and a piece of ribbon was sewn around the top to make the tip of the umbrella. I still have one! The hankie has a dancing baby elephant dressed for a circus with dressed mice playing a sax, a clarinet, and a drum. I always loved it.

Cute hankie umbrellas appeared in a circa 1947 Merry Christmas catalog that offered "hankibrella" party gifts! Very fragile, and not considered keepsakes at the time, hankibrellas are seldom found today. I have been lucky enough to find two. The first came from a lady I met on e-bay when she purchased an old *Highlights* magazine from me. She liked my e-mail address and asked me about it. One thing led to another and I ended up swapping the magazine for her hankibrella. I was thrilled. I found the pink hankibrella in a favorite thrift store sitting all by itself on a shelf. I paid one dollar for it and left wide-eyed and smiling.

Vintage *hankibrellas*. Value $5-10 each.

LACE OR CROCHET TRIM?

Ladies were still decorating their own hankies in the late 1940s. Decorative edgings books were published by Coats and Clark, Star American Thread Company, and The Spool Cotton Company. Because fine silks were not available to most 1940s era homemakers, wool and cotton was substituted. These make heavy laces that we now call "crochet." Handkerchief edging books refer to their offerings by a pattern number rather than a lovely name. Lace and crochet trims often use numerous stitch techniques. Whenever possible, the hankies with crochet trims here are referred to by their prominent decorative style.

The quality of lace and crochet trim can be determined by looking closely at the thread condition and consistency of thread tension throughout the piece. The older crochet work is often broken and with stretched threads; usually, these can be rejuvenated. Trims can also be saved and used in other creative projects. Be sure to visit the Lace Gallery at the back of this book to view an alphabetical presentation of lovely lace hankies.

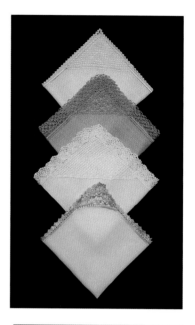

Samples of crochet-edged hankies. Value $10-15 each.

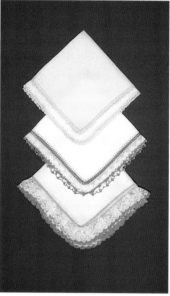

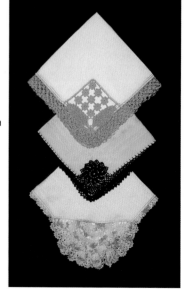

Crochet medallion inset corners of flora and fauna make these hankies a personal best friend. Value $10-20 each.

Solid colored hankies with special edges so ladies could add their own crochet work. Value $1-3 each.

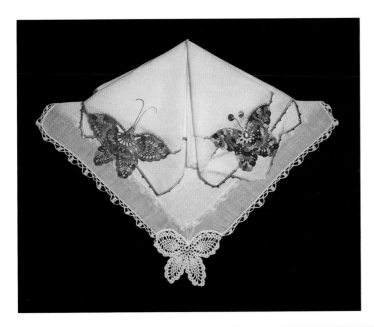

Butterflies catch everyone's eye. The pink butterfly hankie pattern was offered in The Spool Cotton Company's 1949 *Handkerchief Edgings* Book No.256. The wings follow the pineapple crochet motif. The white butterfly is courtesy of Carol Joles and was made by her mother. Value $10-20 each.

Lover's Knot is the dreamy name of this crochet stitch that provides feathery decoration to these hankies. A very lightweight crochet thread is used on this hankie trilogy. Value $10-20 each.

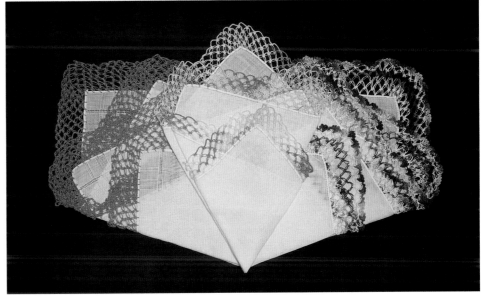

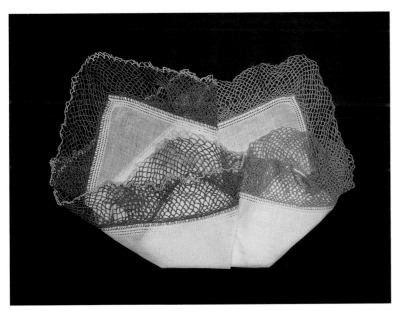

Arch Stitch is repeated in many rows to give a spiderweb look and delicate texture to these hankies. Value $10-20 each.

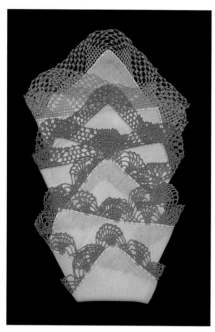

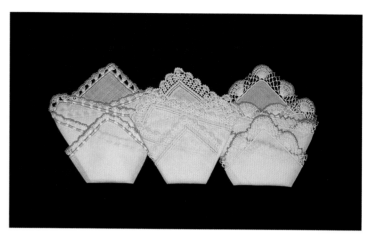

Crochet edging stitches made with heavier weight thread give a colorful distinctive design pattern. Value $15-25 each.

Top hankie has turquoise threads using mesh double crochet and Solomon's knot stitches.

Middle hankie uses pink threads that start out with a row of open check mesh, flow into lacy scallop stitches, and end with a picot edge finish.

Bottom hankie uses purple threads of single chain stitches connecting honeycomb mesh to the single, then double, and triple stitches to create multiple fan shapes.

Two colors of crochet thread adds that cake frosting look to hankies. A dress or jacket would look great with any of these hankies peeking out of the jacket pocket. Value $15-25 each.

Right hankie has blue filet and picot crochet on top of white fan shapes made from a wide arch base with double to triple crochet stitches. Honeycomb mesh is on the sides of each fan.

Middle hankie has white filet and picot crochet on top of variegated yellow wide arches on top of lacy scallops with open ground mesh next to the hankie's edge.

Left hankie has pink filet and picot crochet on top of white 5-cluster shells.

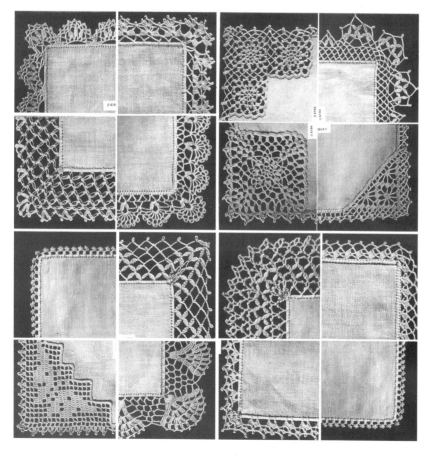

Samples from *The Star-American Thread Company Handkerchief Edgings*, *Book No. 61*, 1948. Looks easy, doesn't it?

1950 TO 1959

THE FABULOUS '50S

Henry Ford introduced the first credit card during the 1920s to make it easy for people to purchase gasoline for their Ford Motor Company cars. This system was further developed by an Italian-American into today's *VISA* charge card. In the 1950s, people could say, "Charge it" for their purchases, and thereby they created a new "consumer society." By then, one person in seven in America had a television in their home. Society was still conservative and people liked the *status quo*, but a desire for new and different goods was being promoted in print and television advertising.

SIGNED BY THE DESIGNER

Recognition for hankie designers came in the early 1950s when artists added their signatures to their hankie designs. But signed hankies did not appear in catalogs, which leads me to believe they were only offered in major department stores. I thought it would be a relatively easy task to compile a few tid-bits of personal and professional information on each hankie designer represented in this book. I spent an amazing amount of time and energy dancing around library aisles only to end up a wallflower. This is really all I found.

In 1952, Tammis Keefe, one of the most famous and prolific hankie designers, was quoted in an article in *Craft Horizons*:

> *Color is the most important factor in handkerchief design…for color prepares the emotions for the design itself, as music sets the mood for a play. It is proper use of this statement that makes it possible to create a telling, capsule statement within a fifteen inch square, whether for fun or fashion.*

She can paint pretty pictures with words as well as her paintbrush.

Virginia Zito, another handkerchief designer, was featured in the March, 1952, *Woman's Day* magazine. The article spotlighted her Easter hat designs, but not her textile designs. Be sure to visit the Designer Gallery at the back of this book to view an alphabetical presentation of creative hankie designers' work.

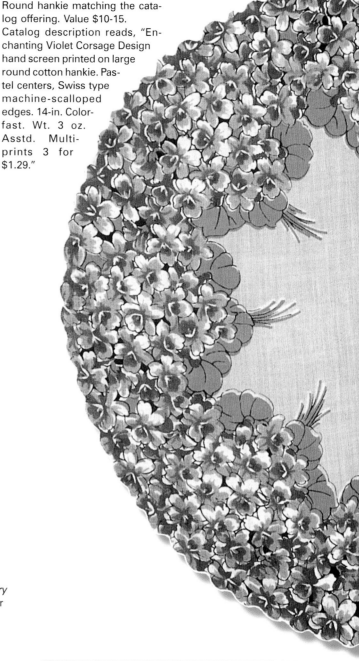

Round hankie matching the catalog offering. Value $10-15. Catalog description reads, "Enchanting Violet Corsage Design hand screen printed on large round cotton hankie. Pastel centers, Swiss type machine-scalloped edges. 14-in. Colorfast. Wt. 3 oz. Asstd. Multiprints 3 for $1.29."

1950-51 *Montgomery Ward* Fall and Winter catalog cover.

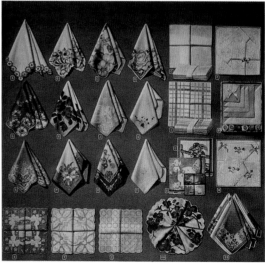

1951 *Montgomery Ward* catalog offerings of ladies' hankies.

BRAND NEW SHAPE

Round hankies with machine-scalloped borders were shown in *Montgomery Ward*'s early 1950s catalogs. The hankies were screen printed with pretty flowers in rich colors. These hankies made cute additions to breast pockets on uniforms worn by nurses, technicians, beauty operators, and waitresses. Be sure to visit the Round Gallery at the back of this book to view additional circular hankies.

1951 *Montgomery Ward* catalog offerings of ladies' hankies.

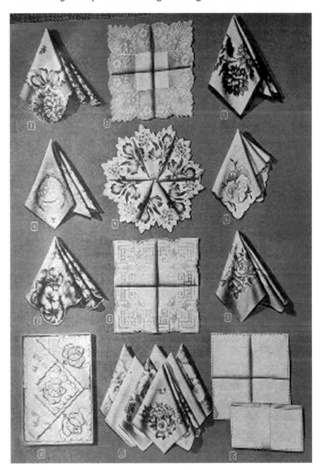

1951 *Montgomery Ward* catalog offerings of ladies' hankies.

Another lovely shaped hankie offered was the four-corner floral design. This hankie was so attractive and popular that there are many still to be found in their original folded condition. Dogwood flowers, in many colors and varieties of patterns, were extremely popular as decorations for scarves and hankies.

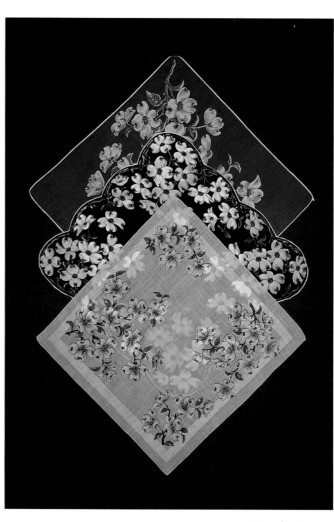

Value $5-15 each.

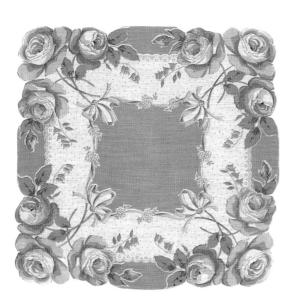

Hankie styles similar to catalog offerings. Large flowers form an all-around border with a scalloped hand rolled edge. Value $5-15 each.

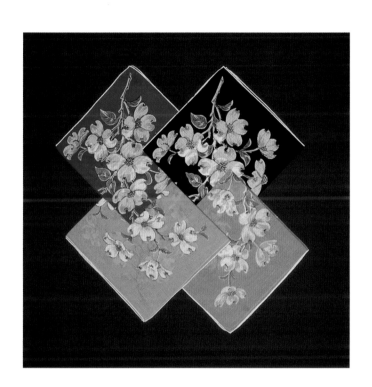

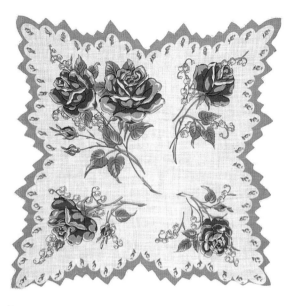

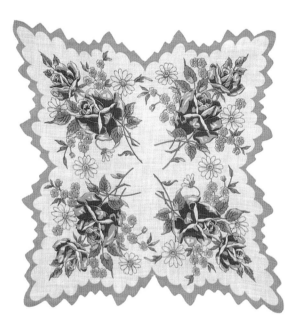

Very spiky, dynamic border treatment. Value $10-20.

Clothing fashions had a lot of flare in the Fifties when ladies wore full, fluffy dresses and petticoats were popular. Scalloped hankies of the period were gorgeous and plentiful.

But ladies' hankie selections in store catalogs were dwindling. The pictures became so small that it was difficult to determine what the hankies really looked like. By 1955, the mail-order catalog hankie fashion engine seemed to be sputtering and the gas tank was getting low.

1954 *Montgomery Ward* catalog hankie selection.

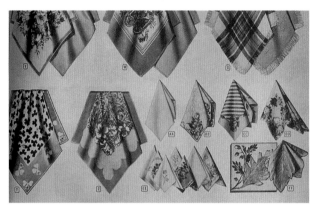

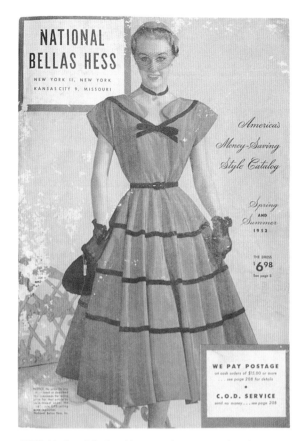

1952 *National Bellas Hess* catalog cover showing the fashion style of the period.

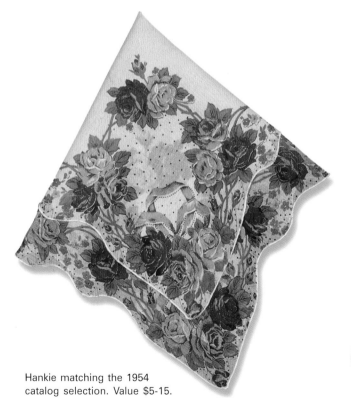

Hankie matching the 1954 catalog selection. Value $5-15.

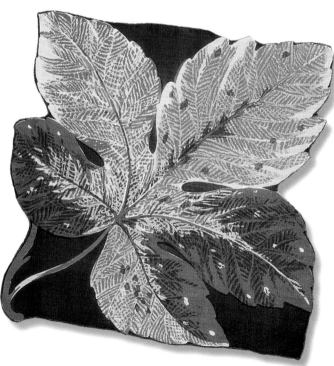

Leaf motif hankie similar in colors and artwork to the catalog offering. Value $10-20.

GREAT RETAIL STORE OFFERINGS

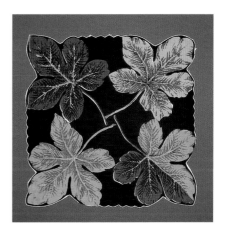

Retail store buyers purchased cloth hankies to be sold as gifts, rather than as an essential fashion accessory. Today, the original price tags on old hankies of the late 1950s help to determine their age and source. Their variety and selection is vast, and they probably were offered through *J.C. Penney Co. Inc.* and similar stores. Today, these hankies are valued at $5-20 each.

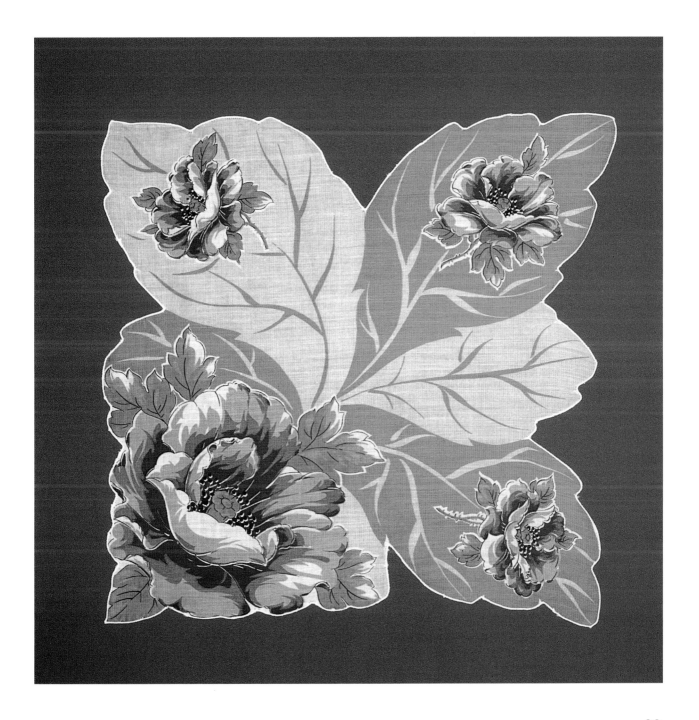

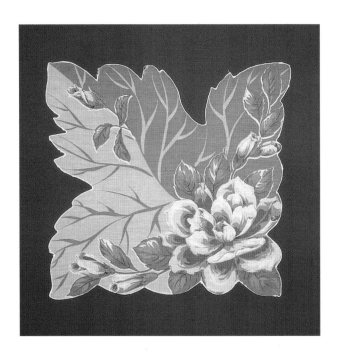

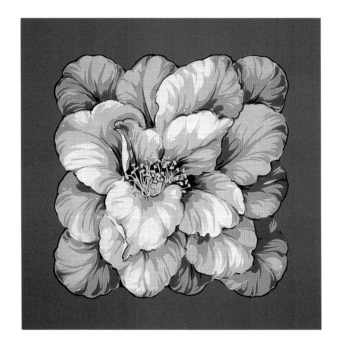

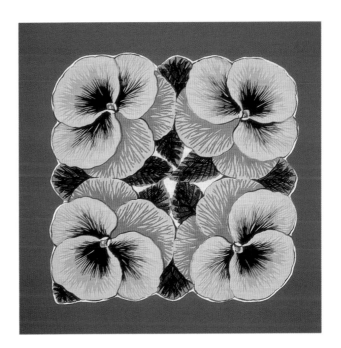

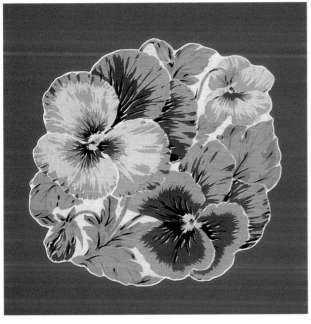

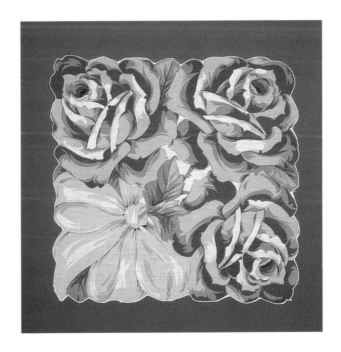

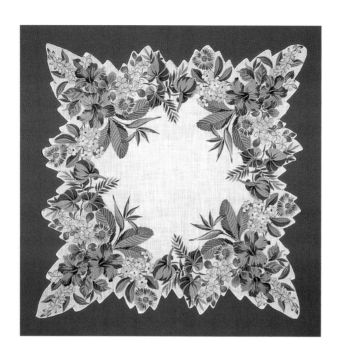

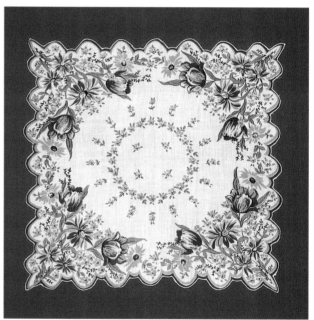

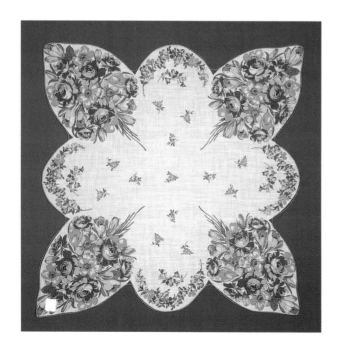

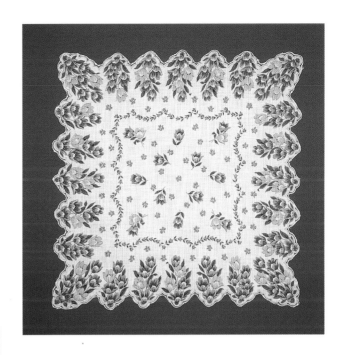

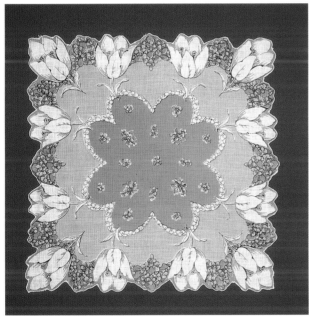

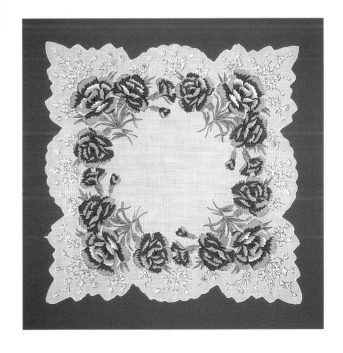

Handkerchief Edging Books

In 1951, the first full color books for handkerchief edgings appeared, and they quickly gained popularity. Thread companies, like Coats and Clark, American Thread Company, Star, Spool Cotton Company, and DMC Cottons, produced beautiful color guides to increase sales of their thread and yarn products. These books provided detailed directions and wonderful pictures of crochet and tatted edgings. Ladies used either plain colored, or floral printed hankies and added hand crochet decorative edgings. Wouldn't it be fun to pull one of these hankies out of your pocket during a dull meeting, today! Values are $10-20 each.

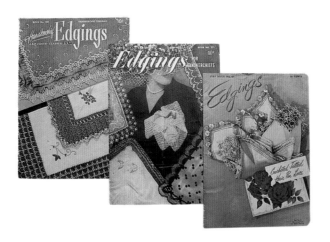

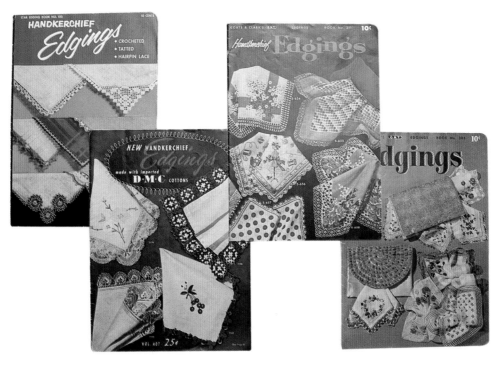

LITTLE LULU AND HER MAGIC TRICKS

The trouble started back in 1924, when paper tissue was introduced as a cold cream remover and disposable facial towel. 1930 consumer tests showed most people were using them as disposable hankies. I hate to be the one to blame *Little Golden Books'* popular character, Little LuLu, for the downfall of the fabric hankie industry, but let's study the evidence. She became the poster girl for *Kleenex* brand paper tissues around 1954. A *Little Golden Book* featuring Little LuLu, published by Western Publishing Company, had a first edition printing of 2.25 million copies. The book was a direct imitation of a previously published magic tricks book by a U.S. cloth handkerchief company. When the *Kleenex* tissue advertising campaign went on, and on, and on, ladies' fabric hankies sales were reduced. They practically disappeared from mail order catalogs and department store shelves. Little LuLu was enticingly cute, in her presentation for *Kleenex*, and provided a solution to hygienic germ control.

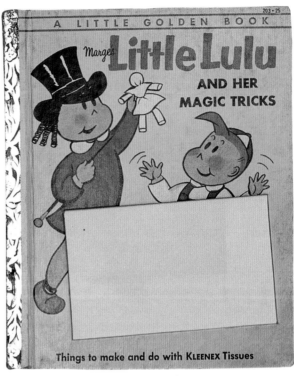

Cover of the book *Little LuLu and Her Magic Tricks*. Value $15-25.

Little Lulu holding a *Kleenex* paper tissues box printed on a counter stand-up display card.

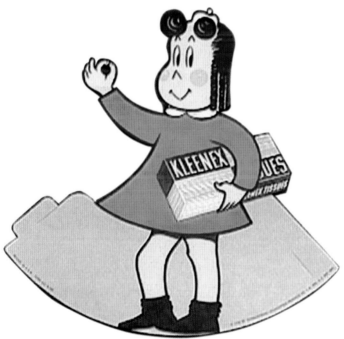

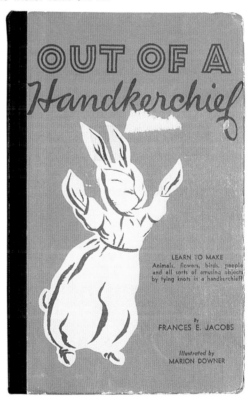

Out of a Handkerchief was one of the books that gave simple instructions how to make hankie items. This book specialized in hankie animal characters.

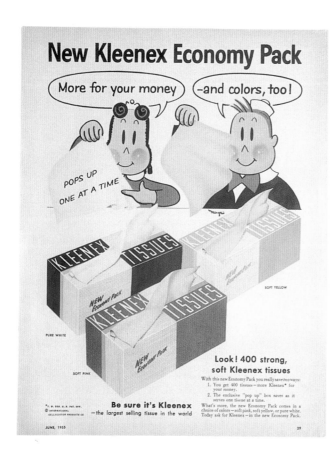

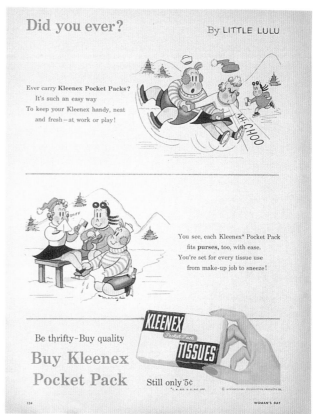

A series of magazine ads for Kleenex paper tissues featuring Little LuLu.

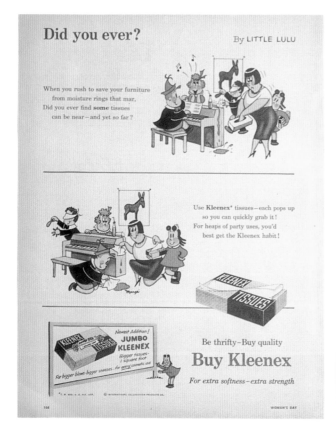

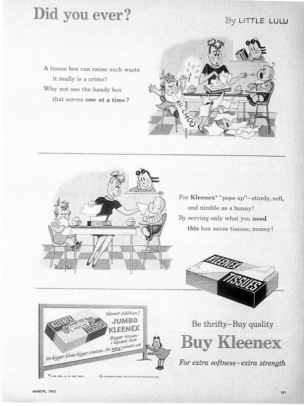

70

THE AUTOMOBILE AND HANKIES

If you are in the age group that used to go for "day trips" and "family vacations" via the car, you will remember hankies with information about each state in America. These were available at retail stores, truck stops, and souvenir stores; and don't forget the roadside trading posts out West. Franshaw handkerchief manufacturer was the primary supplier of state hankies. The popular vacation states of Florida and California are the most commonly and highly decorated of the state hankies. The geographic size and population of each state seemed to determine the quantity of each design's production run. Depending on the condition, state hankies are valued at $5-35 each.

I highly recommend the book *Collecting Handkerchiefs,* by Rosanna Mihalick, (Schiffer, 2000) as the best reference on state hankies.

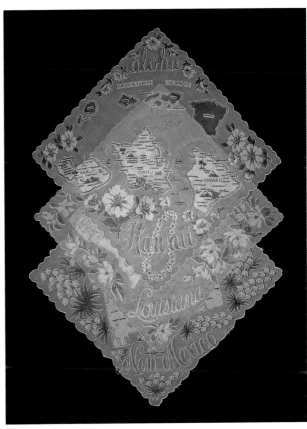

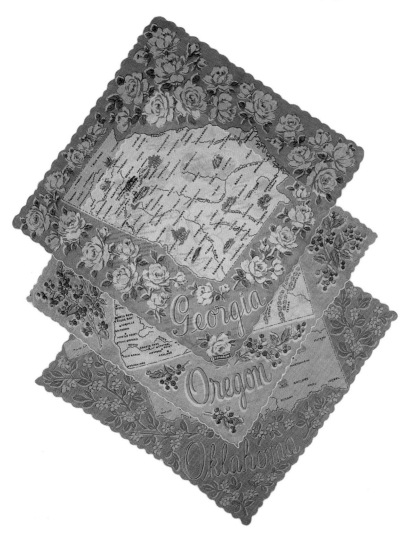

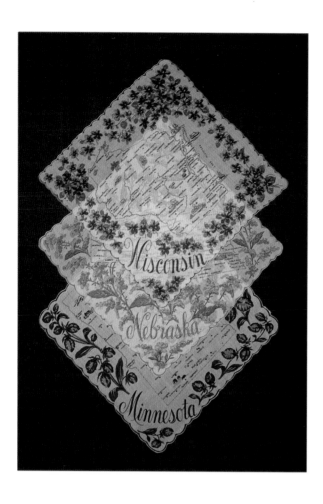

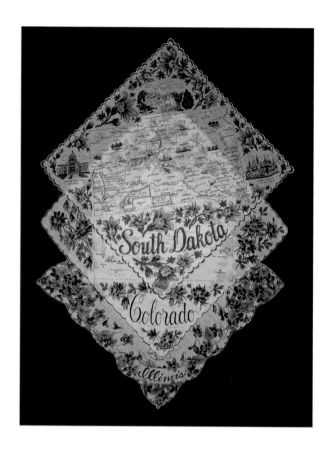

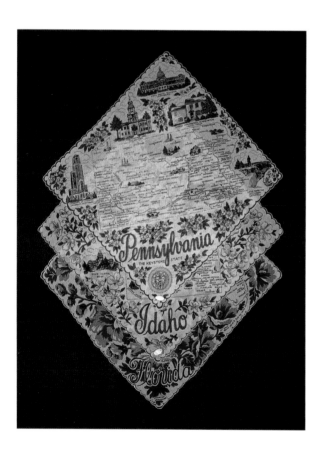

1960S AND BEYOND

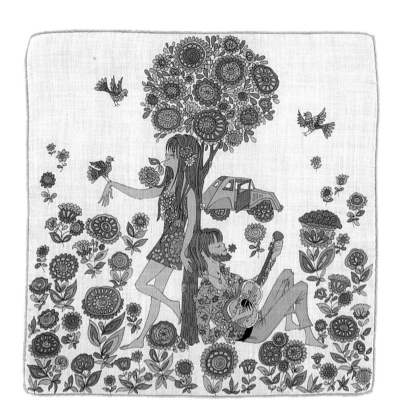

Boxed hankies were still available in the 1960s. They were great gifts for little girls. Value range is $10-40 each, depending on the condition and quantity of the hankies in each box.

Many Baby Boomers (children born between 1943 and 1950) chose very different lifestyles than their parents. Many of the "older generation" had experienced economic depressions, recessions, world war, and women's dramatic role change in society. Most of America's "younger generation" grew up sheltered from those hardships by their parents, bombarded by mass media, enjoying pocket money, and experiencing a better education. Many teenagers and young adults felt invulnerable and engaged in questioning just about everything. A "generation gap" thus formed, and traditions began dropping like the thermometer on a Wisconsin winter day.

One of my favorite memories from the 1960s is walking through the old Woolworth store in Boise, Idaho, to look at the hankie selection. They lived down one of the many straight isles of low store counters. The hankies were stacked and separated into sections by little glass panels. Prices ranged from 35 to 55 cents. I don't remember buying any, I just really enjoyed how pretty they were and they made me feel happy.

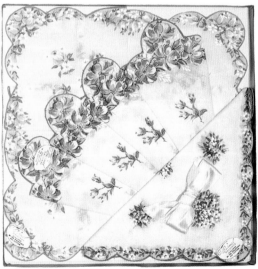

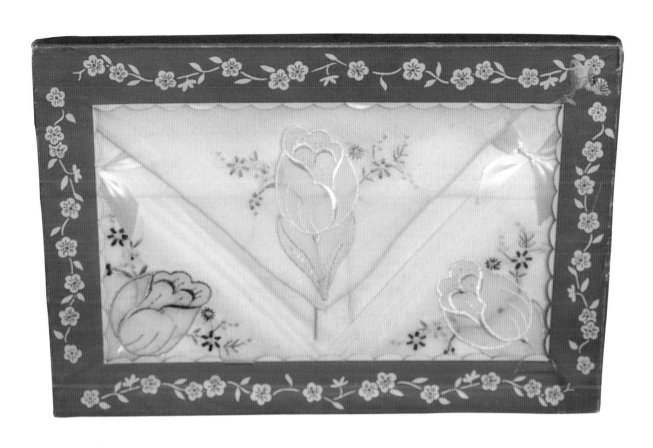

Early 1960s embroidered hankies in gift folders.
Value $5-15 each.

Women were visible in the work force in the 1960s. Poor little hankies just could not survive the intensity of the 1960s environment. They were no longer appreciated as a fashion accessory, required too much maintenance, and silently they gave a halo of feminine vulnerability to their users. Disposable hankies were available everywhere. At the beginning of each new school year, teachers asked students to bring a large box of paper Kleenex to the classroom.

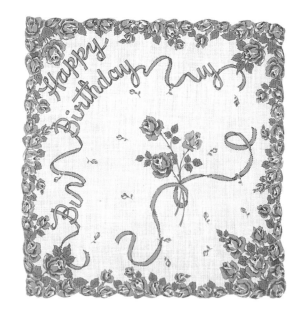

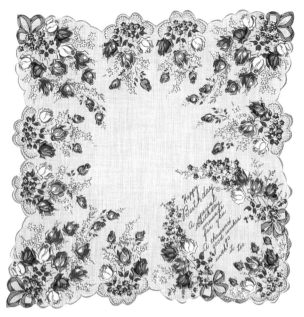

Special occasions were popular themes for fabric hankies. These hankies are from late 1950s and early 1960s. Value $10-20 each.

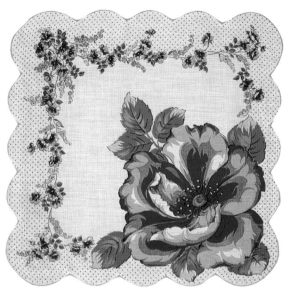

These hankies were acquired from various garage sales, antique stores, and thrift stores. They would be prefect to use today in a wall hanging or as large quilt blocks. Value $10-20 each.

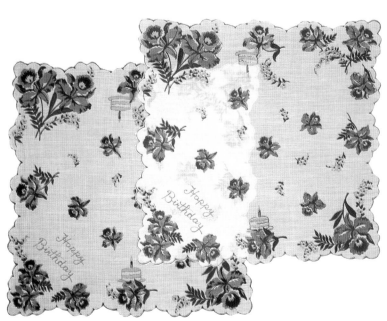

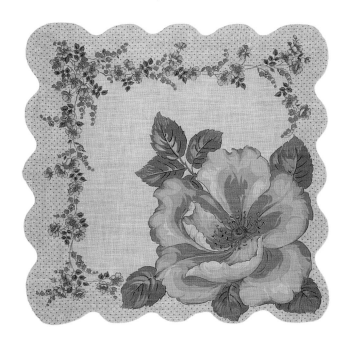

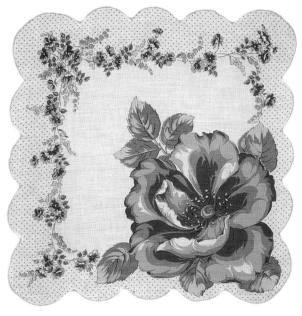

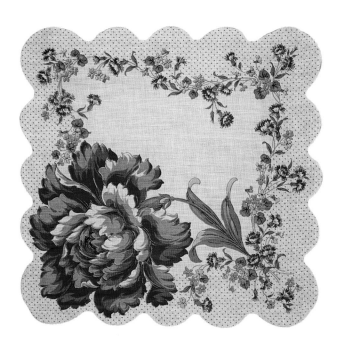

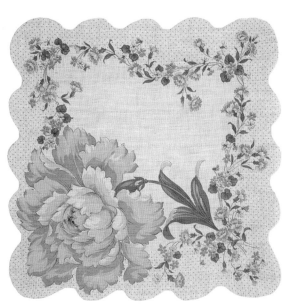

The *National Bellas Hess* 1960 catalog offered hankies in packs as hankie manufacturers continued to compromise production methods to increase the profit margin. They used course fabrics of low thread count and most hems were square cut with stark machine-stitched thread edgings.

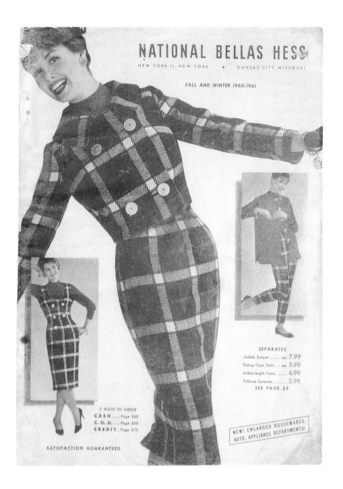

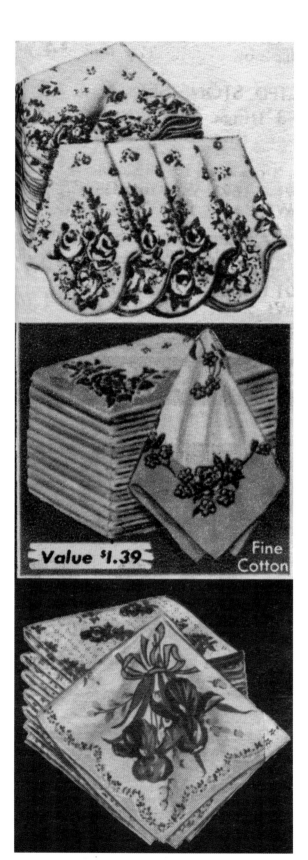

National Bellas Hess 1960-61 catalog hankie offerings.

Hankies of the 1960s. Value $1-5 each.

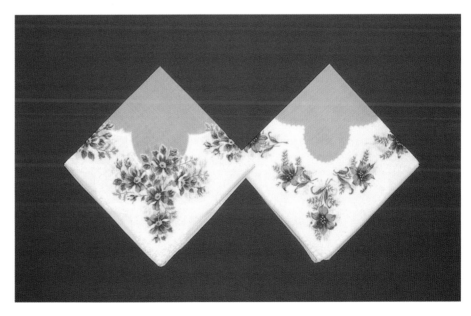

By the time their 1963 fall and winter catalog came out, *Montgomery Ward* had discontinued listing ladies' hankies in their Index; there were a few pretty hankies shown on the page with scarves. Quality printed fabric hankies were placed on the accessories endangered list.

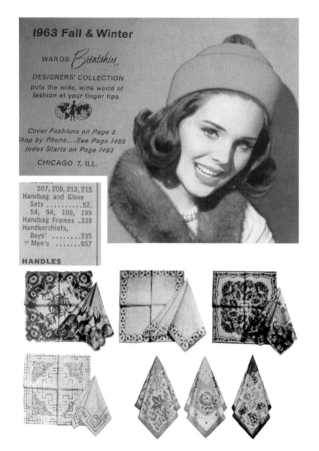

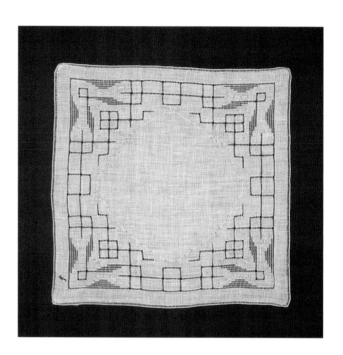

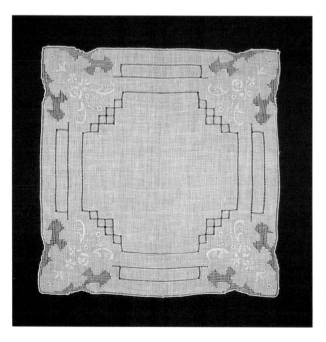

It wasn't all bad news. Lovely imported drawn work hankies like these were offered in the *Montgomery Ward* 1963 catalog. Value $10-20 each.

SOUVENIRS

The United States continued expanding the interstate highways and family car trips had an increased travel range. The colorful printed state hankies of the 1950s were replaced with embroidered souvenir hankies, made in Switzerland. These cotton hankies remained a popular collectible for travelers.

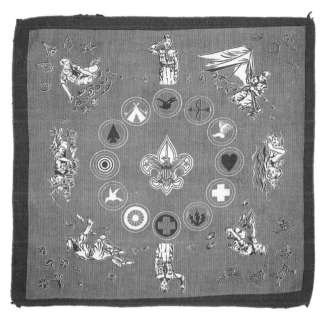

The *Boy Scouts of America* came out with one more handkerchief with illustrations of merit badges and fun activities. Value $10-20.

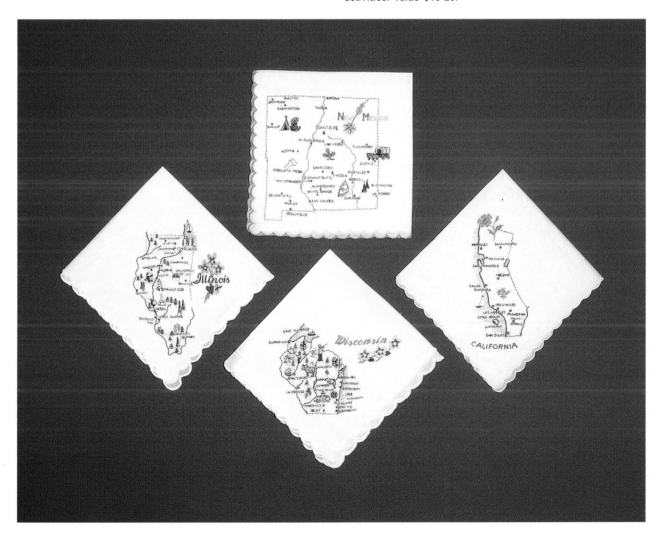

Hankies purchased from Goldmann's department store, in Wisconsin, at the end of the 1990s. Value $1-2 each.

The beautiful gardens of hankies had changed into a parched desert. An occasional little oasis could be found, but overall, fabric hankies had been evacuated from department stores. Ladies were putting their hankie collections into hibernation. Piles of hankies were placed in the backs of drawers, in cedar chests, in boxes placed in the attic, and left in unused purses and coat pockets. Later, these treasures would be reawakened when items were requested for church sales, thrift sales, and the many other methods of reallocating household items. The door was open for inspired crafters and seamstress to recycle these tiny fabric pieces into new decorative creations, such as a dress that appeared on the cover of *Needlework Today* in 1980.

A hankie dress, with instructions, from a 1980 *Needlework Today* magazine.

Hankies purchased from a Walmart store at the end of the 1990s. Pack of six $4.99.

DISPLAYING HANKIES

There are probably thousands of uses for vintage hankies. I always think of the Johnny Apple Seed song, when people ask me what to do with their hankies. Where to start? Consider displaying your hankies, sending them as gifts, incorporate them in decorative projects, framing them, use them as doilies, make them into pillow covers or quilts, and carry one in your pocket. Be sure to visit the Apron Gallery at the back of this book to see a wonderful array of hankie aprons.

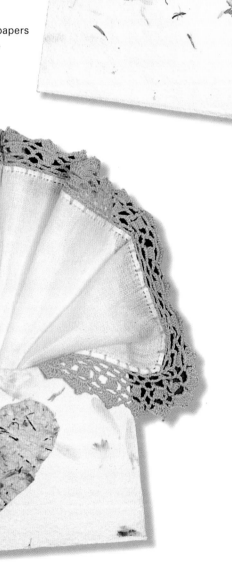

Handmade and commercial specialty papers can be used to make hankie gift folders.

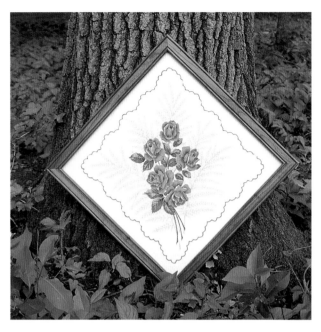

A handmade, cherry wood frame displays a 1950s hankie. *Courtesy of Margaret Ann Gustafson.*

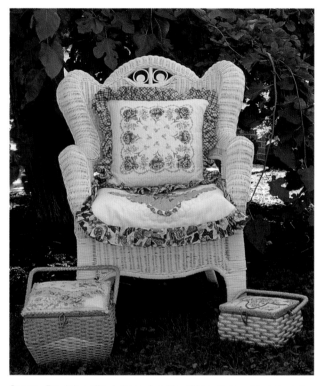

Stacey Pawlak quilted these hankie pillow tops with colored thread. Pieces of hankies were used to recover two old sewing box lids.

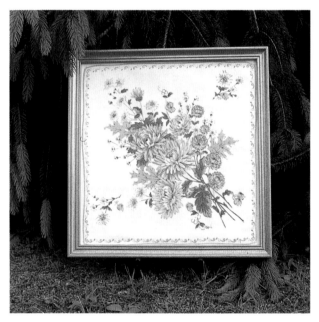

A gold leaf, square frame displays a 1950s hankie. *Courtesy of Darlene Campbell.*

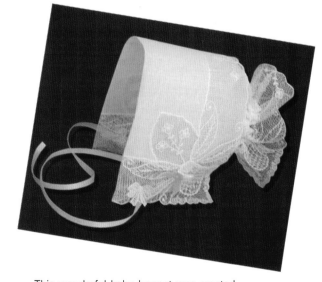

This wonderful baby bonnet was created from a vintage wedding hankie.

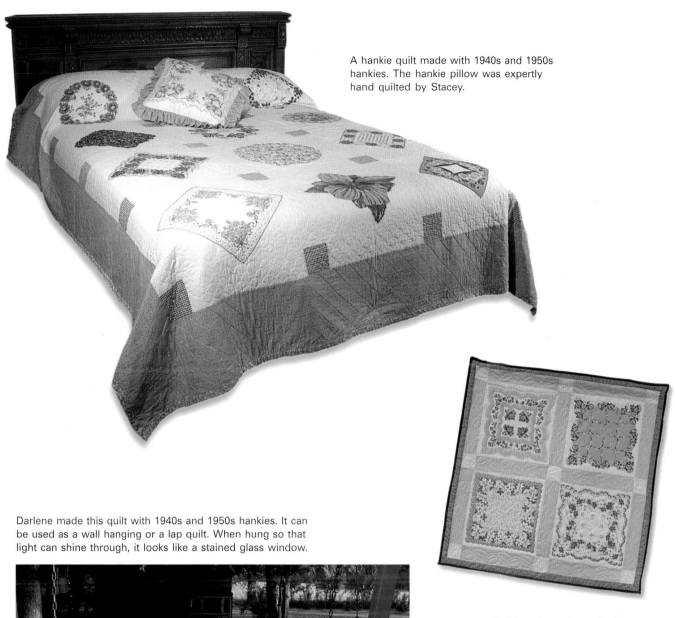

A hankie quilt made with 1940s and 1950s hankies. The hankie pillow was expertly hand quilted by Stacey.

Darlene made this quilt with 1940s and 1950s hankies. It can be used as a wall hanging or a lap quilt. When hung so that light can shine through, it looks like a stained glass window.

Wall hanging quilt made from four 1950s hankies. This would also make a nice baby's blanket.

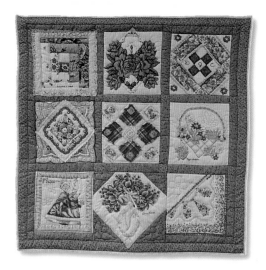

My friendship quilt wall hanging. I provided the hankies and a few written guidelines to my Eau Claire, Wisconsin, Thursday Quilt Group girlfriends. Each quilt block displayed individual creativity, impressive handwork skills, and a cherished friendship. *Finishing quilt work compliments of Stacey.*

FRIENDSHIP HANKIE QUILT

My friends are geographically scattered around the USA. I have enjoyed living in many different states and towns, due to my father's, and now my husband's, professional opportunities. The last time we moved, I decided it was time to make a friendship quilt, something that could travel with me and remind me of the companionship and fun I have enjoyed with my soon-to-be-left quilt group. I thought about each person's color preferences, personality, and quilting styles. I filled kits containing hankies and vintage trim from my stash. Finally, I added a note listing the items inside, some production guidelines, and a few personal suggestions. There was a party atmosphere as each person made her kit selection. We brain-stormed design ideas and a few people traded in their first kit selection for another. A few friends were afraid to even start this project and others jumped right in and had a finished block the next week!

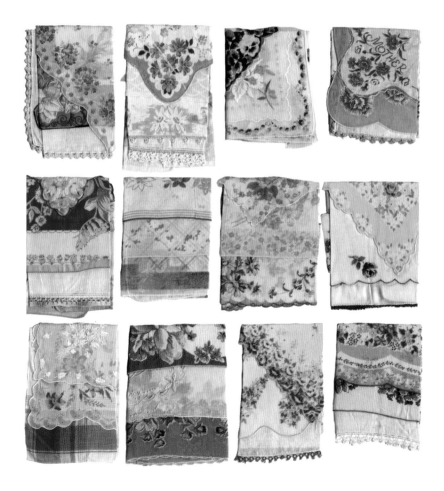

GEOMETRIC GALLERY

Geometric design hankies were first introduced in the late 1920s and gained great popularity in the 1930s. Their visual message ranges from slightly distracting to totally frantic; some are even frenzied! By using the simplicity of lines, circles, squares, and some good vibrations, textile designers created images of magnitude. Their powerful use of proportion, balance, rhythm, and sometimes unusual unity, is stunning. Each of the hankies is cotton, machine straight-stitched hemmed, and approximately 12 to 13 inches square. They were made in the 1930s through the 1940s.

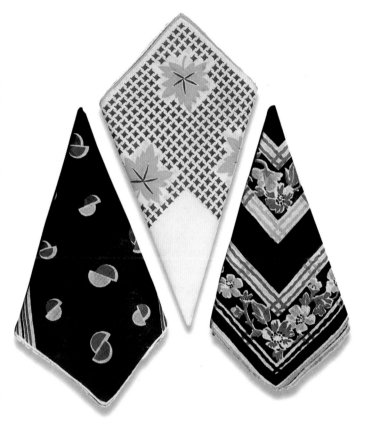

ESSENTIAL SIMPLICITY

Just wiggly lines, dots and a great choice of colors make these hankies distinctive little worlds of their own. Value $10-20 each.

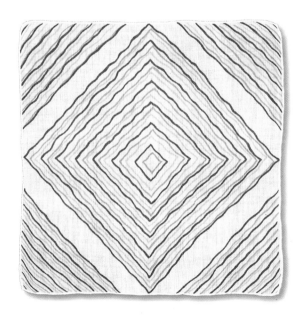

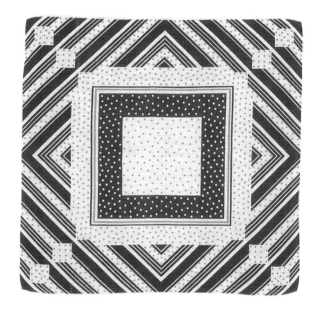

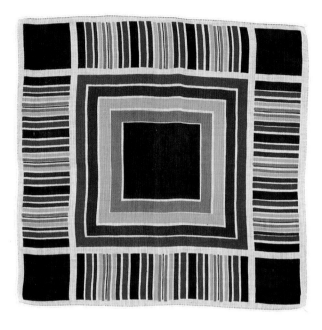

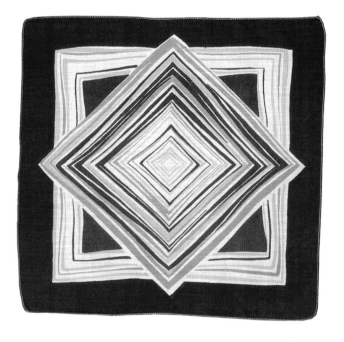

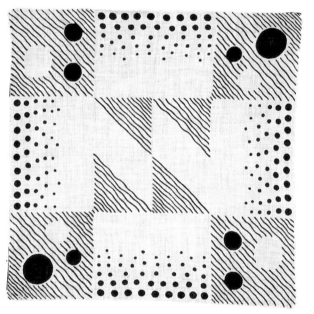

ICON IMAGES

These hankies have designs that would make great company trademarks and logos. These hankies are eye pleasing and quietly distinguished. Value $15-25 each.

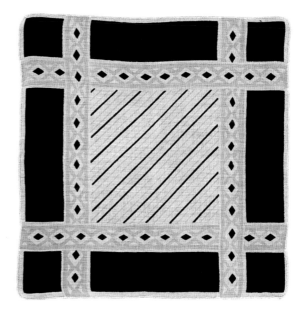

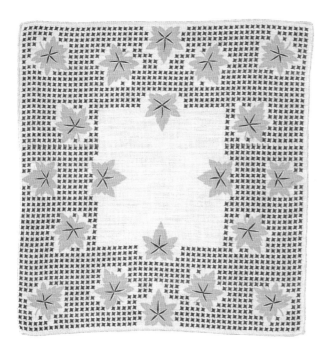

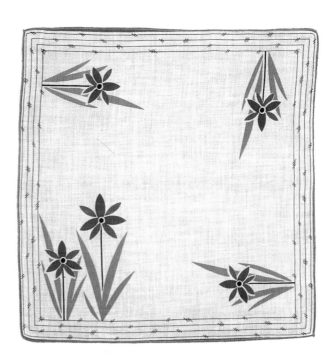

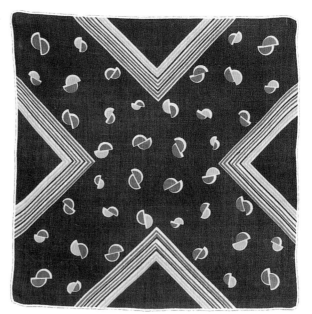

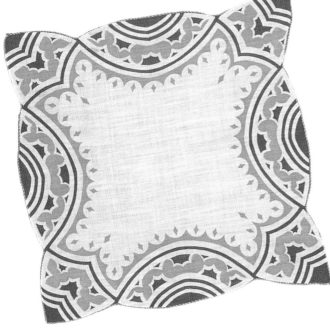

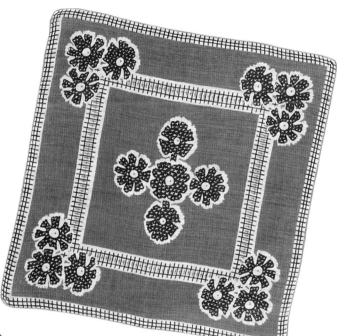

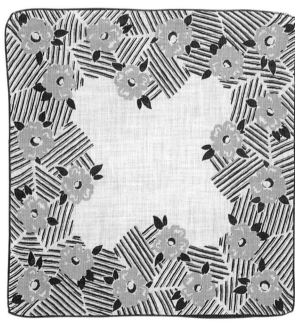

RHYTHM AND BLOOMS

Decorative lines combine with impression-istic floral designs on these hankies. The de-signs range from scant to the copious use of color and images. Value $10-25 each.

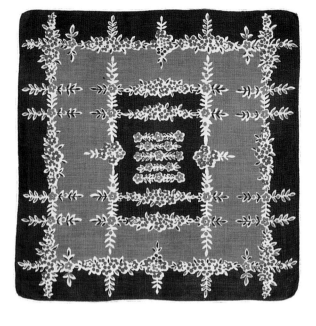

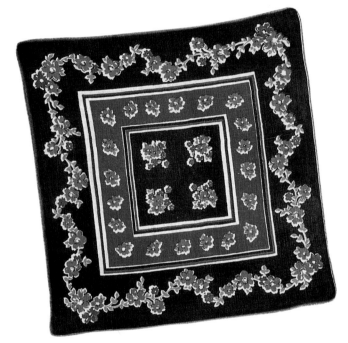

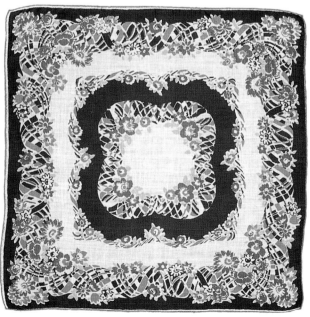

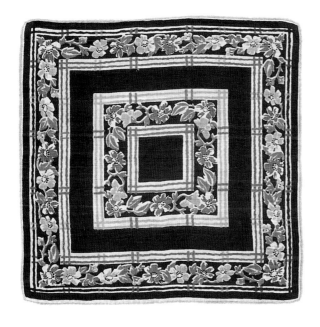

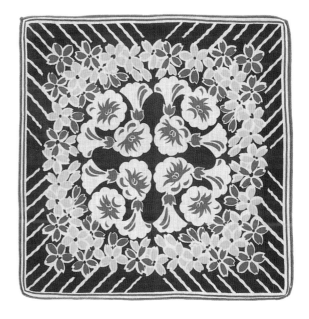

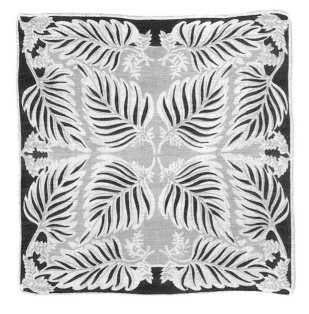

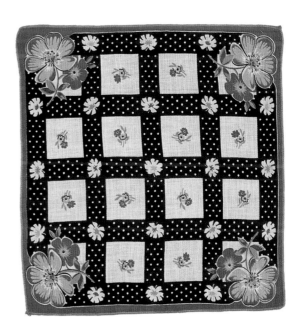

WHEN PATHS CROSS

There are hankies with borders that far out-stage the floral images inside. Graphic elements with issues and statements to make! By crossing the traditional art with textures and graphic patterns, these hankies deserve their placement in the geometric gallery. Value $15-25 each.

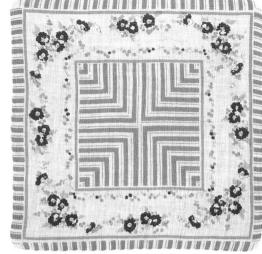

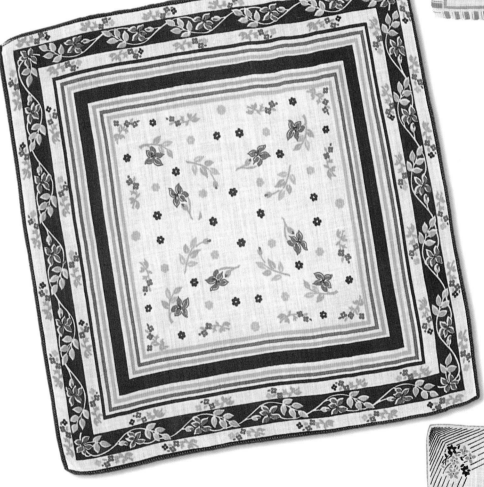

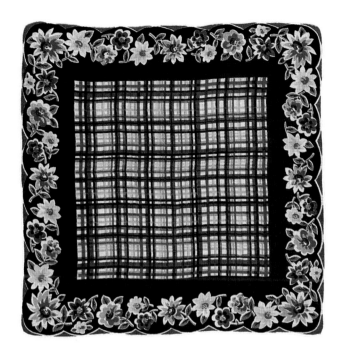

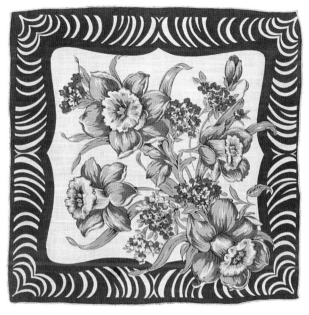

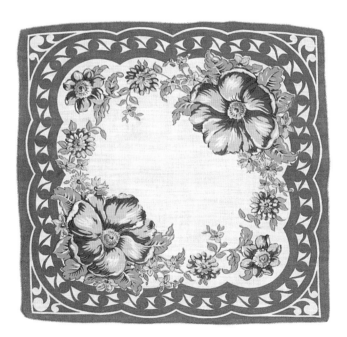

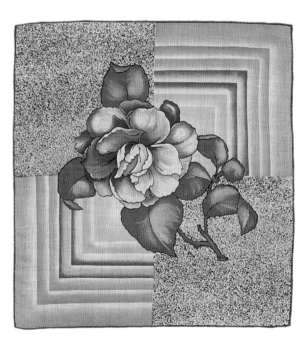

ROUND GALLERY

Circular hankies were produced in a comparatively short timespan during the late 1940s and the early 1950s. The new shape provided a challenge to textile designers in that artwork needed to fit the round canvas, rather than the traditional square area. A high percentage of round hankies have designs with an aerial view of a floral bouquet, with blossoms formally radiating from the center. Other design arrangements mimic border treatments and motifs of their kissing cousins, square hankies.

It is always a wonderful surprise to find round hankies that match or are the same style as a square one you already have. Often, tex-tile manufacturers used the same decorative hankie design and reproduced them in a variety of colors so that the original artwork, film, screens, and printing plates could be reused. A rainbow of colored hankies could then be offered as matched sets or purchased individually.

Unless otherwise mentioned in the photo captions, all the round hankies shown are cotton, with corded machine sewn hems, and were produced during the 1950s. Two Swiss companies, Kreier and Stoeffel, were the major manufactures of these pretties.

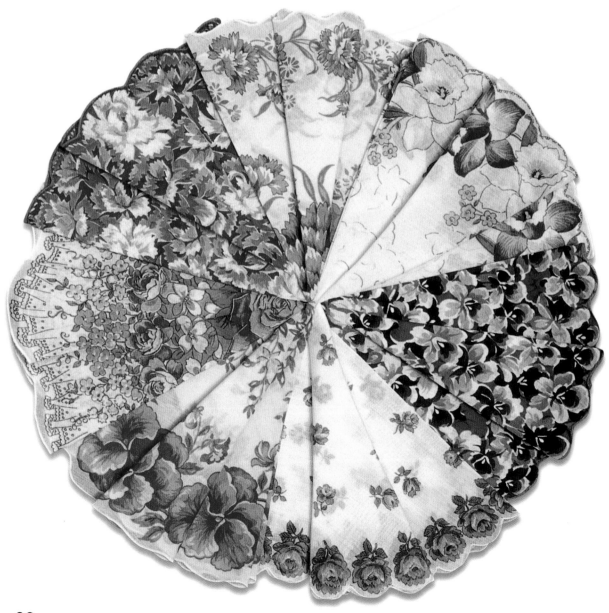

ELABORATE BORDER CUTS

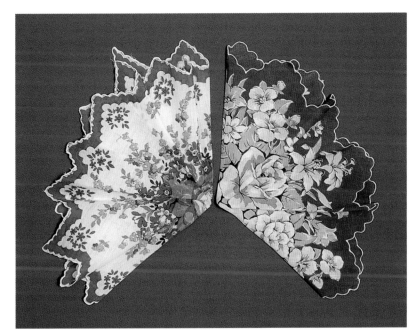

The outside edge of a hankie can be it's most dramatic feature. Deeply cut complex border trims are obviously desirable and extremely collectible.

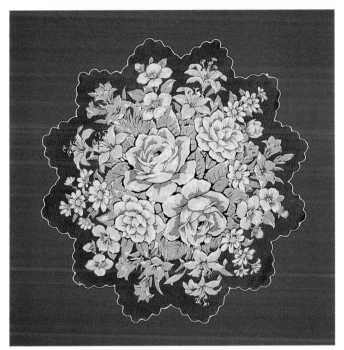

A gingerbread-brown hankie with a scallop-cut border even further decorated by an additional tiny scalloped corded hem. 14 inches across. Value $15-25.

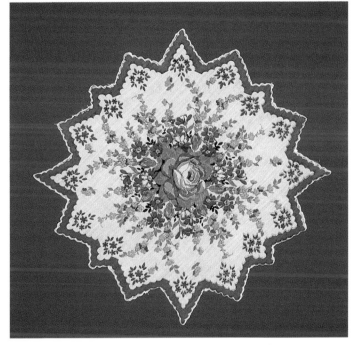

Small scallop-cut edges silhouette this glorious cut-zigzag border. Like high heels on Marilyn Monroe, the blue printed, scalloped, pin-strip border adds a heightened elegance. 15.5 inches across. Value $15-25.

Ferris Wheel Florals

Rotating floral images are the sole of round hankie prints. This hankie style can be folded into a small pie-shaped section to represent the entire design.

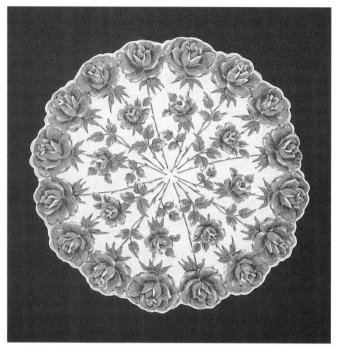

Pretty pink roses "to have and to hold." The scalloped hem follows the outline of each border blossom. 13.5 inches across. Value $5-15.

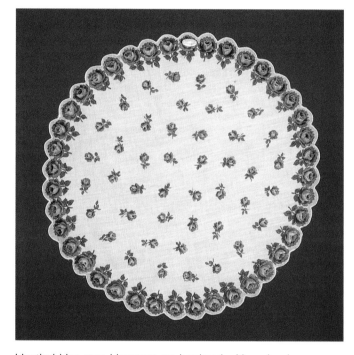

Identical blue rose blossoms are bordered with a closely spaced, scallop-cut border. 13 inches across. Value $5-10.

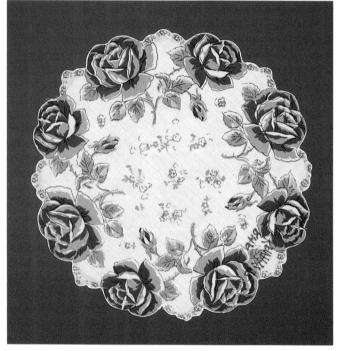

This was Rita's hankie, I know because she wrote her name on it! This was a common thing to do so that hankies didn't get misappropriated during their travels, especially to laundry land! 13 inches across. Value $2-5.

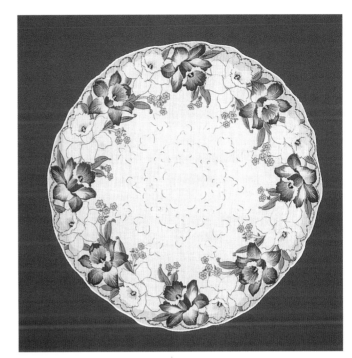

This hankie has a plain edge that is almost blunt cut, but offers a stretched-out trembling of a lazy scallop. 13.5 inches across. Value $5-10.

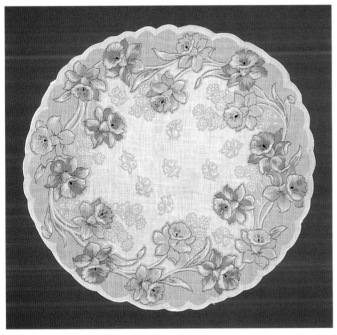

White shadow printing accents the scalloped edge and center of this big hankie. 15.5 inches across. Value $5-10.

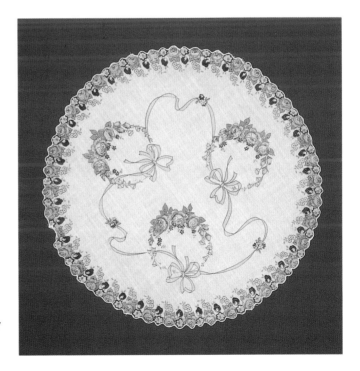

Ribbons and roses float around this pretty hankie that could be given as a gift for special occasions. Value $10-15.

FAMILY REUNIONS

These are some of the round hankie "reunions" I have made during years of extensive hankie hunts. They would make pretty pillow covers for a lady's boudoir or brighten a window seat. They also make great little doilies.

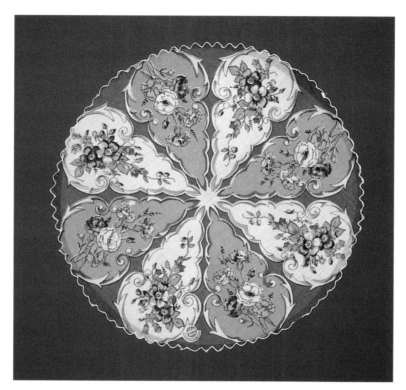

The label reads, "A *Cambridge Original* imported Swiss fabric." The pink hankie has decorative border artwork that does not appear on the blue hankie. It might be possible that this border design was too difficult to print in registration so the manufacturer of the blue one decided to just cut the troublesome border design off! 13 inches across. Value $5-10 each.

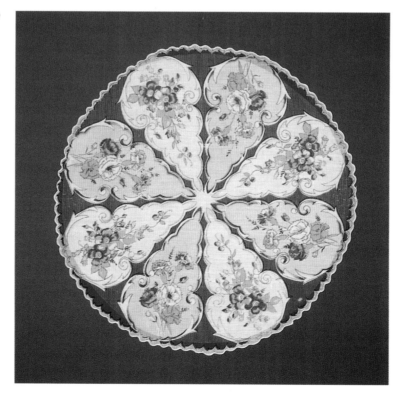

These two hankies are truly "shabby chic." The printed lace ruffles are wonderful. One
hankie was found in Wisconsin and one in Arizona.13.5 inches across. Value $10-15 each.

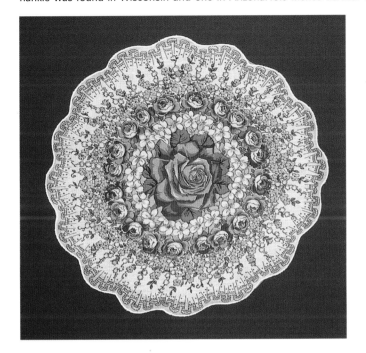 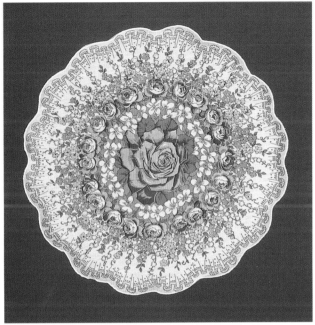

Not twins, but certainly relatives. See their similar placement of the green leaf and the use of
a solid color for the rolled hems. 13 inches across. Value $10-15 each.

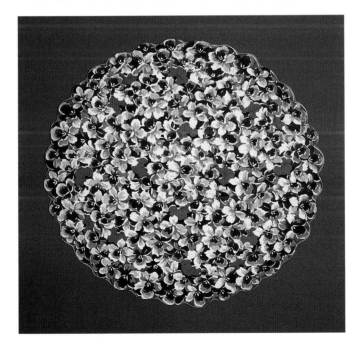 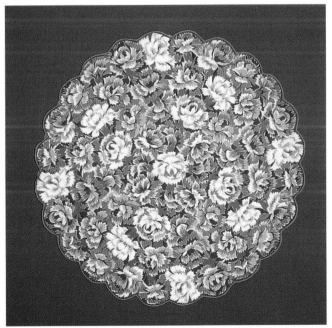

TARGET DESIGNS

Some round hankies have one item per-
fectly centered in the middle, like a bull's eye
target. Your eye is uncontrollably drawn to the
center, then the rest of the circular design
comes into focus, and finally the entire image
can be enjoyed.

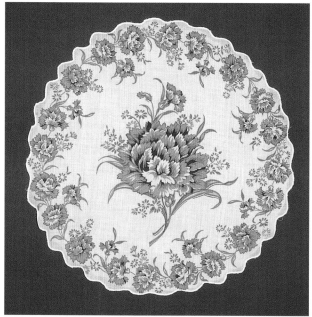

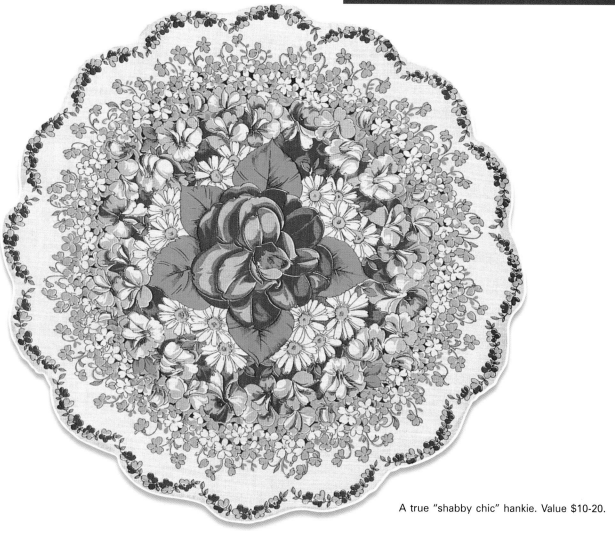

A true "shabby chic" hankie. Value $10-20.

102

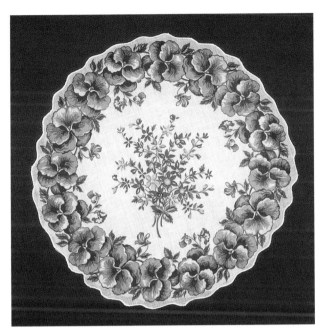

Another "shabby chic." Value $10-20.

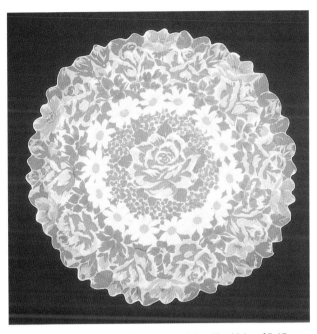

Pastel colors on an extra-large, round hankie. Value $5-15.

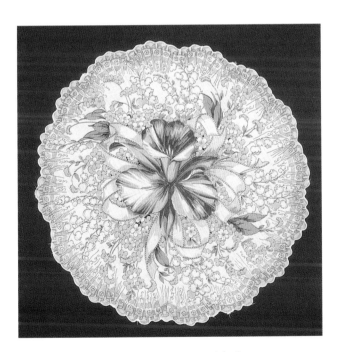

A delicate purple flower with ribbons. 13 inches across. Value $10-15.

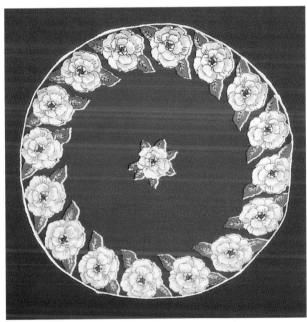

A bright red hankie with a straight-cut border that detracts from its overall attractiveness. Beware of low quality hankies with hems that have been loosely machine stitched and surrounding border material that is poorly trimmed away. This hankie would be a pretty addition to an appliqué project. 13 inches across. Value $2-5.

PLAIN OR PEANUT CENTER?

These plain-center hankie designs are especially effective for quilt projects because the blank spaces in the centers provide wonderful areas for stitching designs.

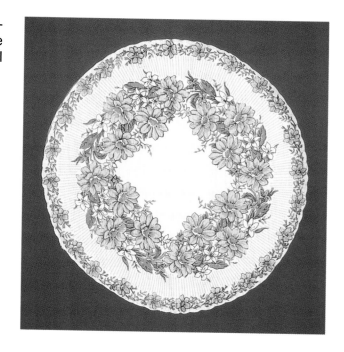

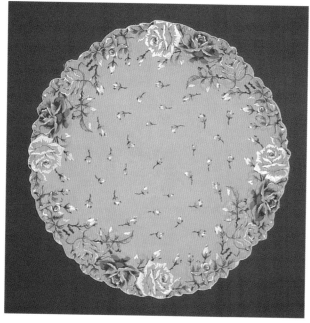

This nylon hankie is 14 inches across. Value $5-10.

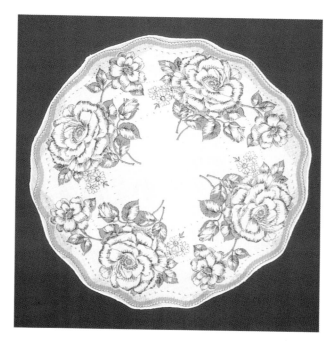

ROUND WANT-TO-BES

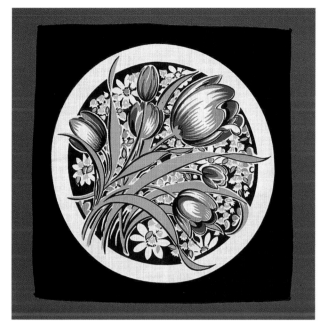

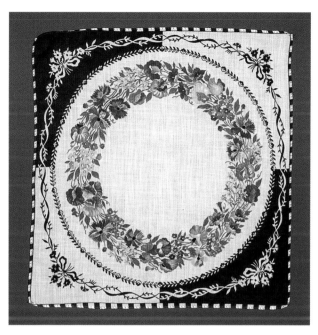

A wonderful Art Deco design. 10.5 inches by 11 inches. Value $10-20.

The following hankies are cotton with wonderful, soft-rolled hems. Value is $10-20 each.

These cute hankies wish they could have been cut into round shapes, but apparently it was easier for the manufacturer to cut them into squares. Too bad!

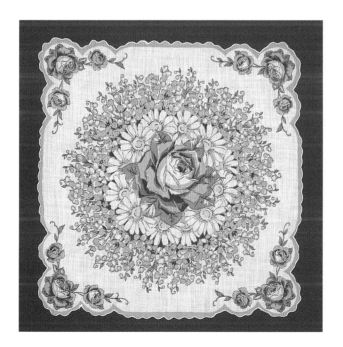

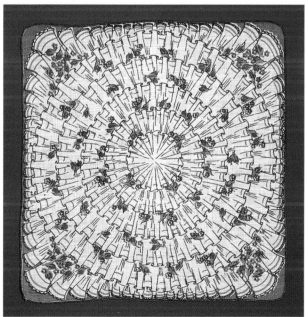

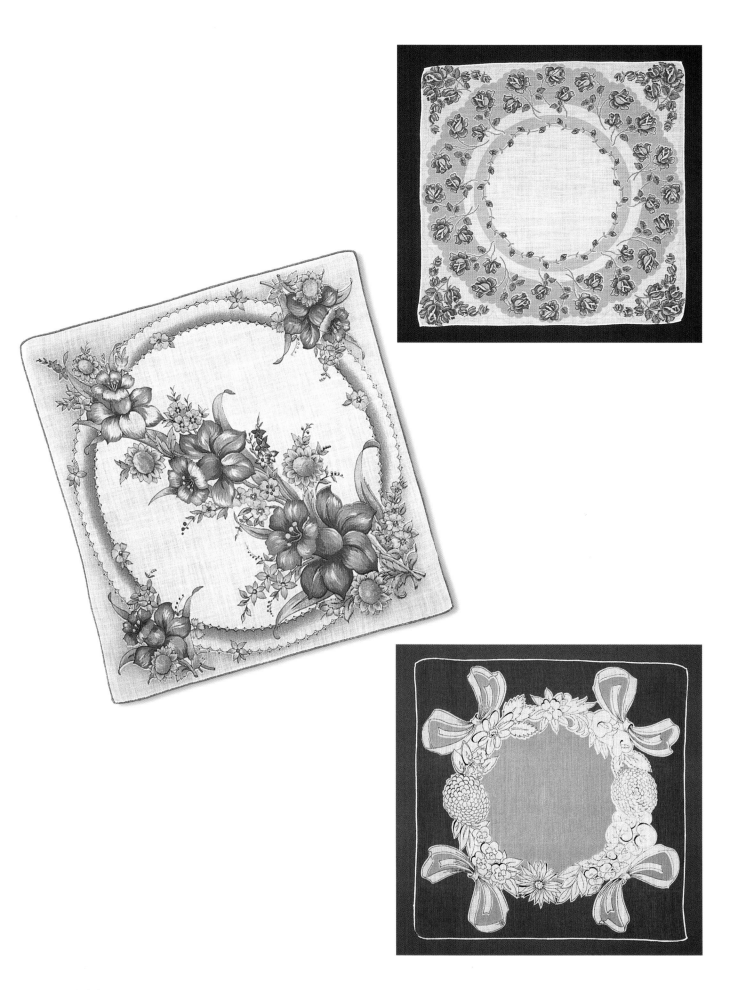

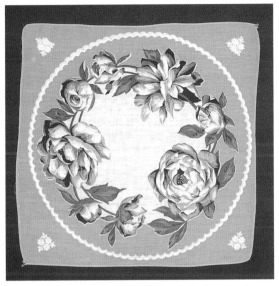
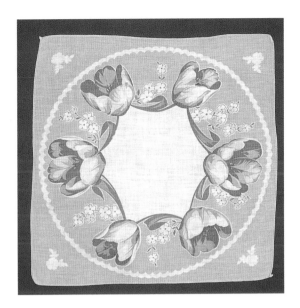

Two inexpensive, folded, straight-stitch, hemmed hankies. 13 inches across. Value $5-10 each.

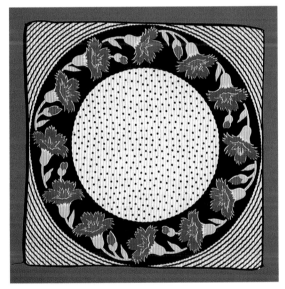

A superior hankie with an Art Deco wreath design. Value $10-20.

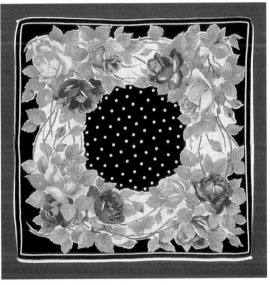

This hankie certainly has a lot happening! Value $10-15.

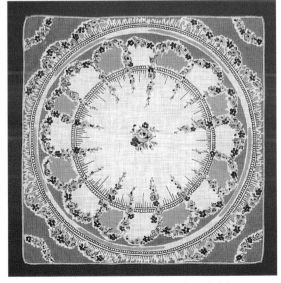
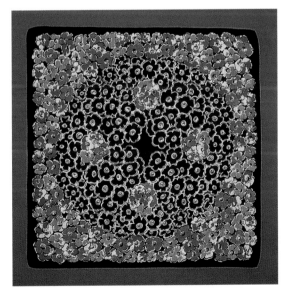

These elegant hankies are linen with rolled hems. Value is $15-20 each.

DESIGNER GALLERY

Discovering hankies that are signed by the designer was, to me, like visiting a new wing of an art gallery. The printed images on these often left traditional floral designs aside for humorous and simplistic, everyday designs. Large areas of blank background surround each design, with a minimum of colors. Most have a lovely rolled hem, often in a contrasting color, which provides the perfect frame for these conversation items. After touring this gallery, you will recognize several of the designers' artistic styles before you see their signatures.

The designers are listed in alphabetical order, including people not represented by a hankie in this gallery. Perhaps you have one of these in your collection!

Unless noted otherwise, these hankies are all circa 1950s, 15 inches square, and linen with soft rolled hems.

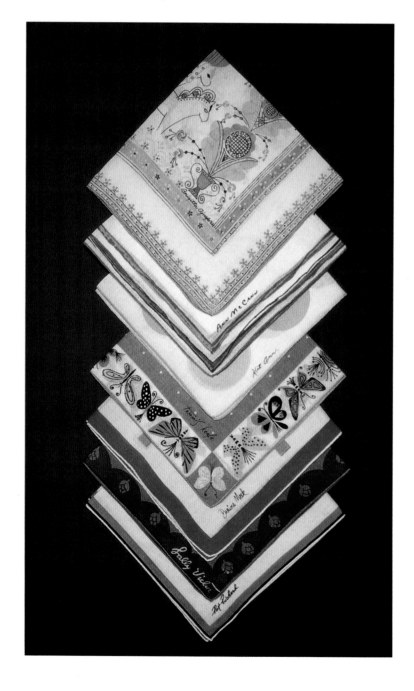

Hankie Designers Menu

Look for hankies by these designers:
Brigitta Ajnefors
Betty Anderson
Kit Ann
Faith Austin
Brooks Cadwallader
Cecilia
Cecil Chapman
Colette
Jo Copeland
Chris Fisher
GiGi
Kati
Tammis Keefe
Billy Kompa
Mary Lewis
Anne Mc Canne
Diane Meek
Jeanne Miller
Monique
Nicole Nelo
Em Jo Pe
Pat Prichard
Anne Samstag
Caroline Schnurrer
Carl Tait
V. Turnier
Peg Thomas
Sally Victor
Virginia Zito

Children's Hankie Designer Menu

Grace Dayon: introduced the Campbell Soup Kids imprint on hankies
Aurelius Battaglia: illustrated nursery rhyme hankies for Golden Books
Tom Lamb: created original playful animal characters to adorn children's hankies
Carl Schultze: signed his hankies "Bunny," in case you are lucky enough to run across any of his designs
Gustaf Tenggren: illustrated many Little Golden Books and hankies

KIT ANN

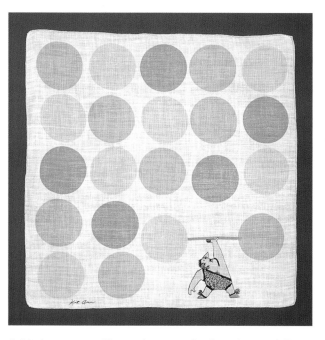

A fabulous sense of humor here; so simple and powerful! Kit's hankies are very collectible. Value $10-15 each.

BRIGITTA AJNEFORS

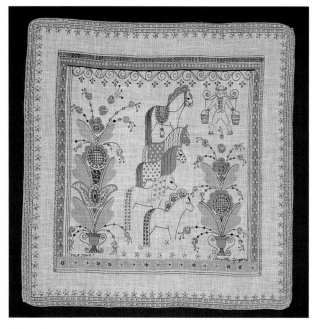

Brigitta liked to title her hankies. This one is "Folk Song." She also created hankies entitled "Spring" and "Smorgasbord," with similar playful border designs and color pallets. Brigitta's hankies are very collectible. Value $15-20.

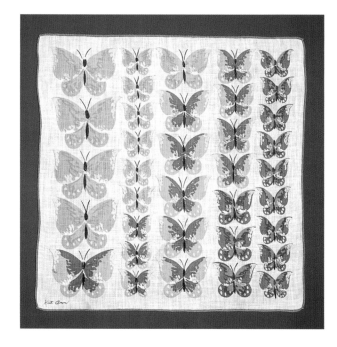

FAITH AUSTIN

CECILIA

Faith uses large areas of neutral color and adds accents with brighter colors. Faith's hankies are extremely collectible. Value $10-15 each.

Lovely Athena figures softly occupy this hankie's stage. Cecilia's hankies are rare and collectible. Value $10-15.

CECIL CHAPMAN

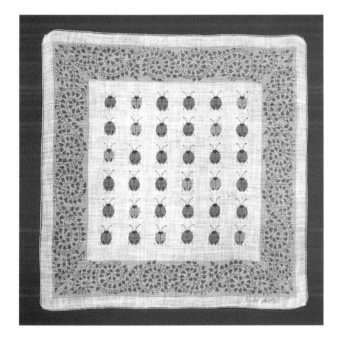

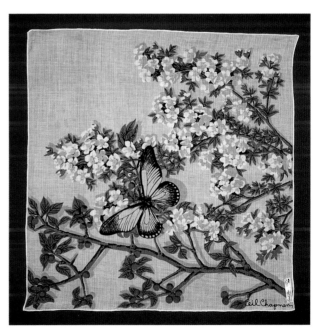

This accomplished illustrator offers a butterfly's world. Cecil's hankies were printed by Carol Stanley Studio. They are not often found and are very collectible. Value $15-20.

COLETTE

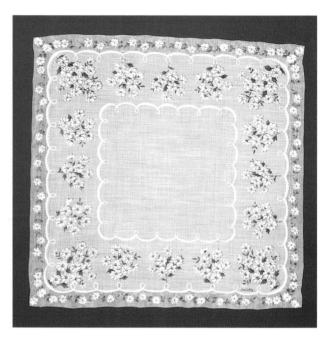

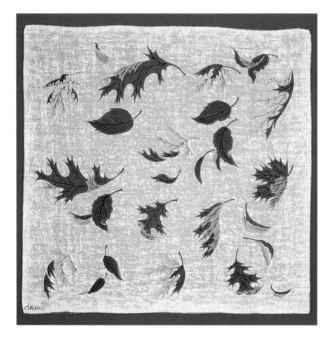

One of Colette's very nice designs. *Courtesy of Linda Rutschow*. Value $10-15.

Colette's work is wildly varied in quality and creativity; each one is drastically different. Perhaps the manufacturing company used the name Colette on hankies designed by several mystery artists. Sorry Colette! Value $5-10.

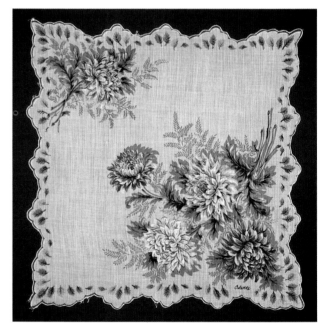

Be discriminating when collecting Colette-signed hankies. Value $1-5.

JO COPELAND

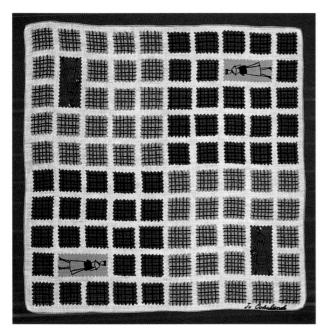

Jo's hankies present an interesting anomaly. These two have similar design styles and color choices, but the signatures are extremely different. I would love to know the story behind that! Jo's work is not often found and is very collectible. Value $15-20 each.

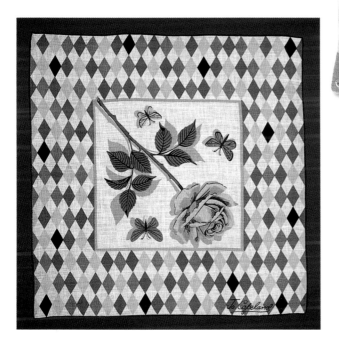

CHRIS FISHER

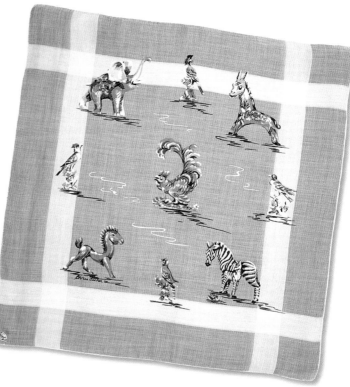

Chris was one of the Burmel designers. This hankie breaks away from the traditional Burmel designs. The drawings look as though they could be made into cute ceramic figurines. Chris's hankies are rare and make interesting additions to a collection. Perhaps circa 1960s. Value $10-15.

KATI

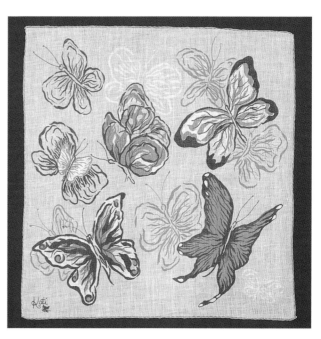

Obviously a cat person, Kati would always add a little drawing of a kitty after her signature. Her designs are loose and fluid. Value $10-15.

GIGI

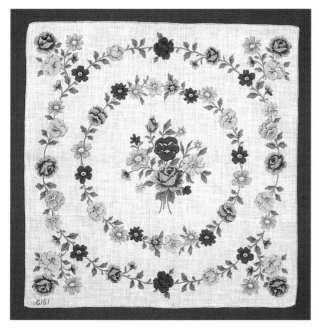

Charles Boyer, the famous 1930s and '40s film star and singer, comes to mind for some when the name "Gigi" appears. Gigi's hankies are not often found and are very collectible. Perhaps circa 1960s. Value $15-20.

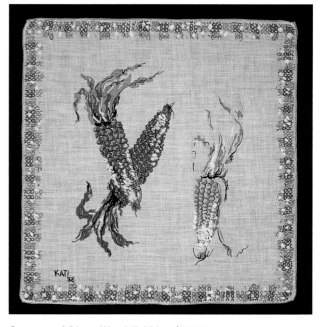

Courtesy of Diane Woodall. Value $10-15.

Tammis Keefe

 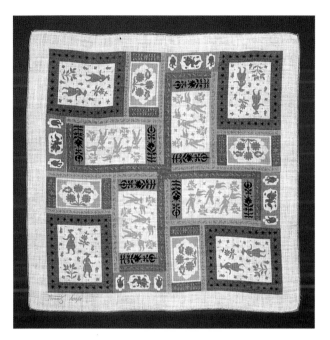

Tammis is one of the most prolific and talented hankie designers. She spent a lot of time on the organized placement of design elements. Her images are well thought-out in a mechanical way and attractively presented. Tammis's hankies are very collectible.

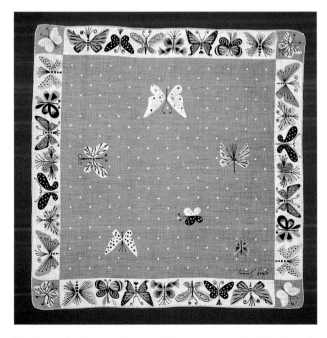 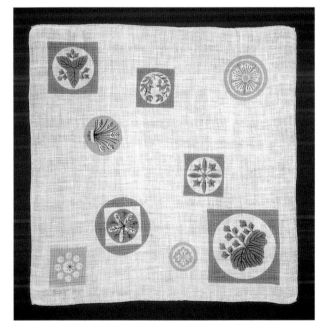

Keefe hankies in excellent condition are valued at $15-25 and hankies in good condition are valued at $10-15.

ANN MC CANNE

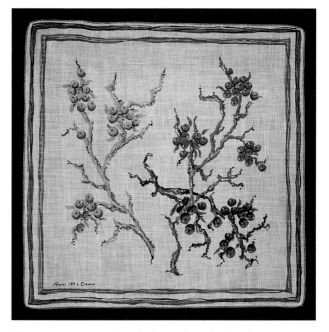

These two are exceptional pieces. Ann designed some hankies similar in style to those of Pat Pritchard, but these two are wonderfully original: one dark image and one light image of the same subject matter, shown side by side, with the impact of an Asian bamboo-brush watercolor. She designed for Kimball. Value $10-15 each.

BILLIE KOMPA

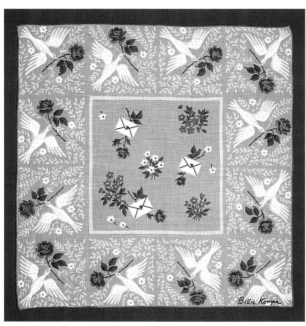

Billie has designed the perfect, tasteful, sweetheart hankie; it is not too alluring. Subject matter certainly adds to a hankie's appeal. Value $20-25 each.

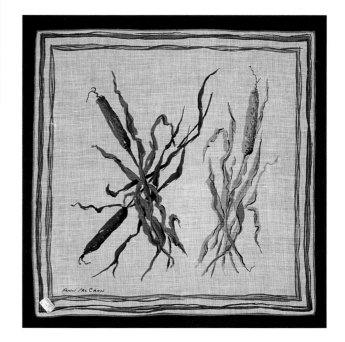

DIANE MEEK

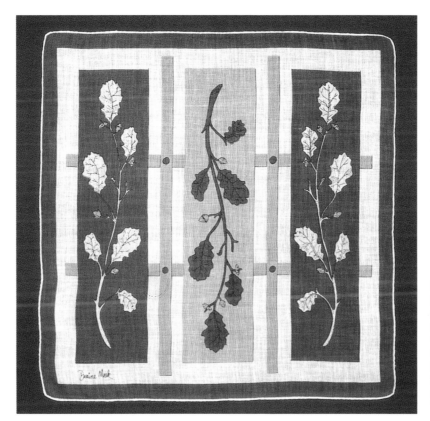

Diane used fine lines to draw the images and added flat blocks of color that filled each area. It is nicely executed art. Diane's hankies are not often found and are collectible. Value $10-15 each.

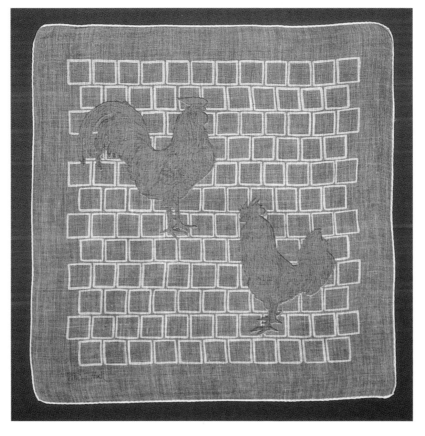

Jeannie Miller

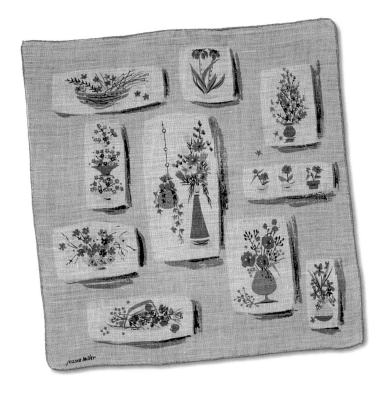

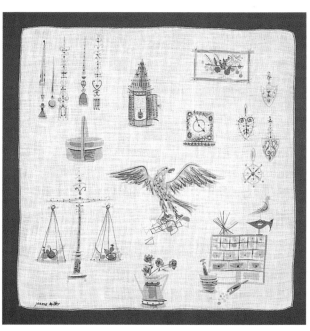

Here is another extremely productive hankie designer. Many of Jeannie's hankies are available and are very collectible. Jeannie designed for Kimball. Value $10-15 each.

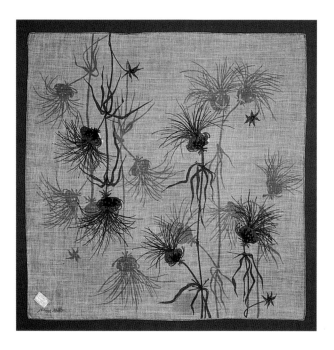

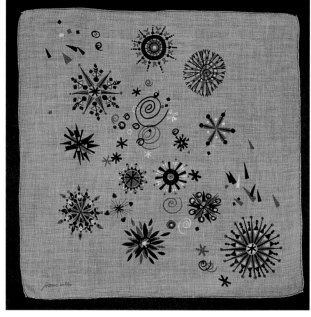

Monique

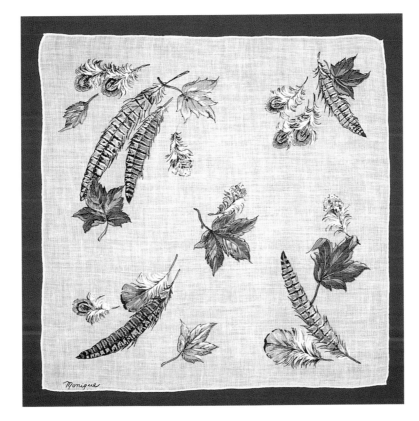

Monique's artwork is distinctively reverent in its presentation of elegant, yet humble, images. Value $10-15.

Em Jo Pe

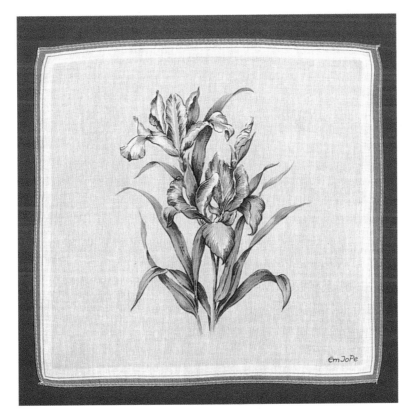

This hankie is small in size with a lovely purple iris specimen, circa 1960s. Value $5-10.

PAT PRICHARD

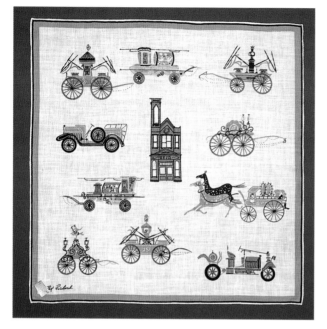 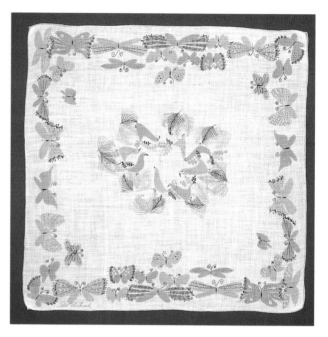

Another designer who was extremely productive is Pritchard. Kimball sold many Prichard hankies. Value $10-15 each.

ANNE SAMSTAG

This designer's name is difficult to read, so please excuse and correct if it is wrong. Anne designed this monochromatic, whimsical, poodle. Her hankies are rare and very collectible. Value $10-15.

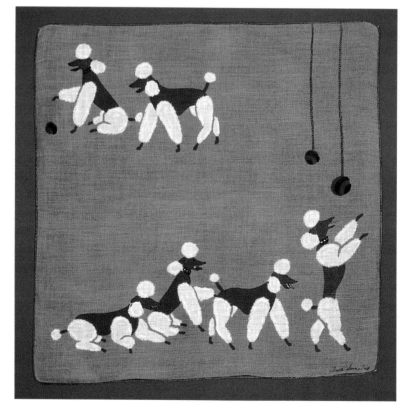

CARL TAIT

SALLY VICTOR

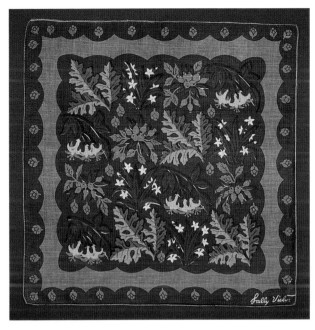

Carl uses loosely drawn cartoons to humorously decorate his hankies. Value $10-15.

Sally is more famous for her hat designs than her hankies, so her hankies are extremely collectible and rarely found. Value $15-20.

VIRGINIA ZITO

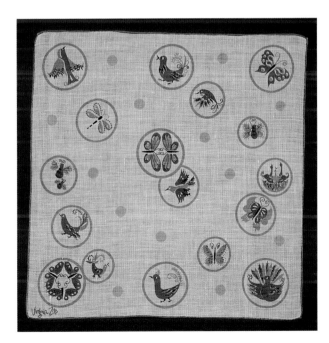

Virginia has the best last name in hankies! Apparently she loved periwinkle blue and birds too. Her work is very collectable. Value $10-15 each.

LACE GALLERY

Something old,
Something new,
Somethng borrowed,
and Something blue!

Lace hankies are welcome at the celebrations of life, anniversaries, and weddings. These small and elegant cloths are traditionally passed along through generations. Not only are laces hankies beautiful, but their names are delightful as well. There are almost as many lace designs and styles as stars in the sky.

Find the name of your hanky's lace or trim by locating the closest "look alike" in the following illustrated alphabetical list. The hankie styles shown here can be currently found by a watchful shopper in antique markets today.

Lace Manufacturing Techniques

Here is a short list of thread and fabric manipulation techniques used to create beautiful laces. All these lace techniques were originally handmade and can now be reproduced by lace-making machines.

Appliqué Lace technique

Threads, and sometimes fabric, applied on top of a net ground. Sometimes the net is cut away from behind the fabric appliqué designs. Hankies with appliqué lace are often found in white and pastel colors.

Bobbin Lace technique

Handmade lace made by manipulating many long bobbins wound with thread. The threads can move in any direction to weave intricate designs. It is sometimes called Pillow Lace because a pillow can be used to support the bobbins and lace during production.

Drawnwork technique

This is a way to manipulate tightly woven, crisp, linen fabric. Individual horizontal and vertical threads are pulled out of the fabric weave and tiny stitches are applied to accent and define the remaining geometric shaped open areas.

Embroidered Net Lace technique

A medium weight thread is lock stitched or chain stitched into net to typically form simple wildflower outline designs. Then a lighter weight thread is needle run inside the outlines to shade in the petals and leaves.

Guipure or Battenburg Lace technique

This method was developed to imitate Bobbin Lace. Cloth tape is curved into flowers and patterns and then secured with delicate thread bridges. Netting is not required as a ground but often a preprinted pink cloth is used as a design guide and temporary ground.

Needle Lace technique

These are stitched laces created by using the buttonhole stitch and blanket edge stitch. Lace variations are formed by varying the distance and tightness of these stitches to form cloth-like areas or spider web open areas. Needle Lace is found in many different lace styles.

Needlework Lace technique

A needle is used to draw threads through a net ground to create pretty designs. These hankies have a hand made look and can be extremely elaborate. They can be found in one or more thread colors including metallic decorations. One common stitch used in Needlework Lace is called couching.

Chemical Lace technique

A natural fiber ground is used and cotton threads are machine embroidered onto the surface. Then the ground is chemically dissolved in boiling lye. Only the embroidery thread remains. Chemical Lace has a somewhat rough crochet appearance. Chemical Lace hankies are also called Wedding Lace hankies.

Lace Styles

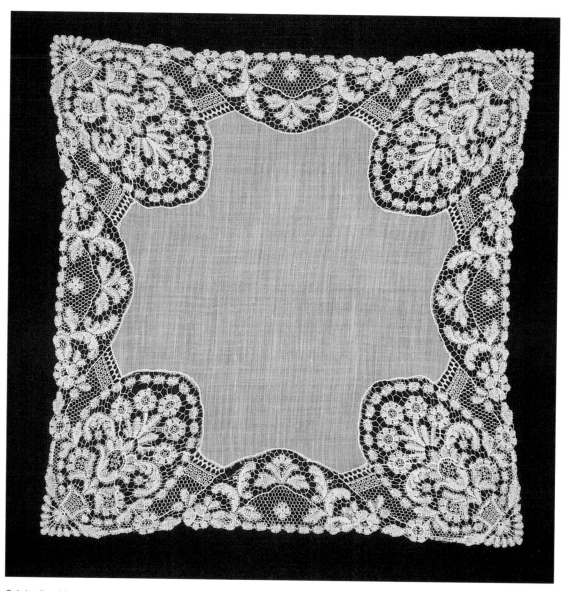

Originally, this was a Needle Lace design from France. It is distinguished by a *cordonnet,* or single strand of heavy thread outlining the designs and secured with buttonhole stitches. Often, the outer edge of the hankie has shallow scallops and a picot finish, as shown here. If you find a very thin clear thread, like fishing line, hanging loose on the outside edge, *do not pull it off*. It could be horsehair that is found on much older lace hankies. Value $20-35.

ALENCON LACE STYLE

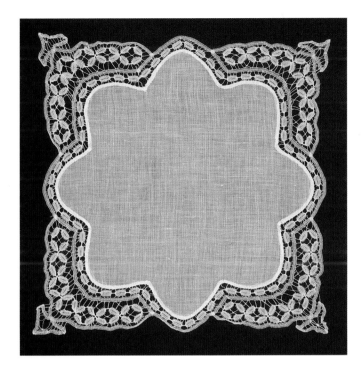

This is a totally American creation by New Yorker, Sara Hadley. There is no mesh background used in the purest form of this Battenburg lace. The decorative designs were pre-printed on pink fabric. Small basting stitches would hold cloth tape to the top of the pre-printed pattern, then they were joined by bridges of twisted threads and buttonhole stitches. Upon completion, the basting stitches would be clipped loose from the pink backing. Other types of Battenburg Lace are Princess Lace, as shown here, Modern Point, Honiton, Duchesse, and Brabant. Value $20-35.

BATTENBURG LACE STYLE

A pink cloth base has a printed pattern to guide the hand-application of Battenburg tape that creates this lace. Value $10.

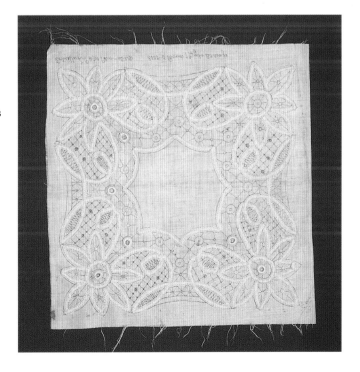

BELGIUM LACE STYLE

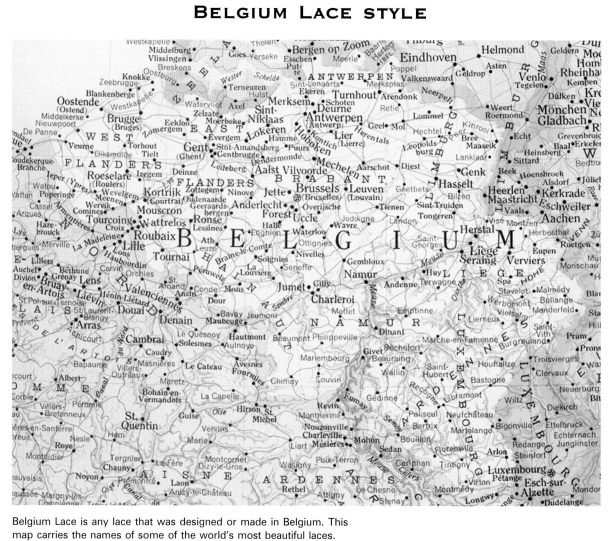

Belgium Lace is any lace that was designed or made in Belgium. This map carries the names of some of the world's most beautiful laces.

BROCADE BAND LACE
STYLE

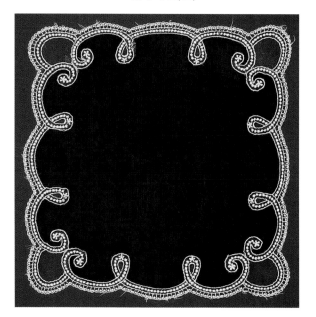

Brocade Band Lace has a net foundation with thread woven into decorative patterns. It can be found with gold and silver thread designs. Value $10-20.

BRUGES LACE STYLE

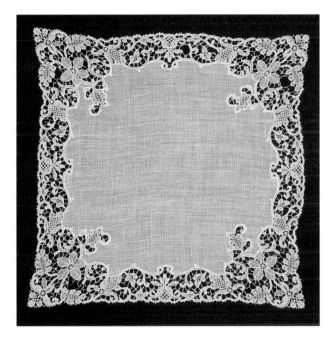

Often called flower work, Bruges Lace uses no mesh and the bridges have little barbs on them like rose stems. Value $20-35.

BURATO LACE STYLE

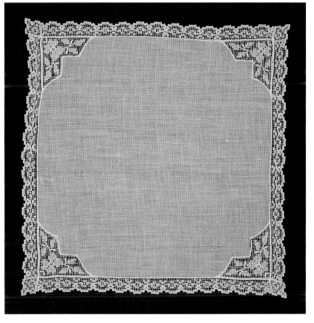

Distinguished by a square thread grid with additional stitched to form solid areas, this is similar to Filet Lace, but more rustic in appearance. Value $20-35.

BUCKS POINT LACE STYLE

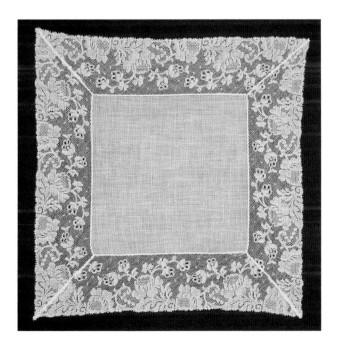

Originally a Bobbin Lace, linen threads form fabric inside the outlined floral designs. This lace can be found covered elaborately with floral designs. Similar lace styles are Binche, Valenciennes, Malise and Mechlin Lace. Value $10-20.

CLUNY LACE STYLE

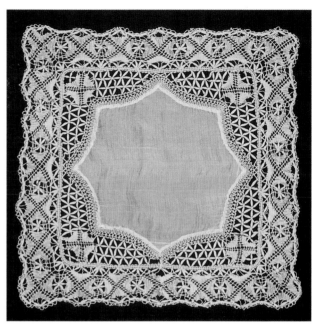

This lace is made without any mesh. Daisy-like wheels are common. France, China, and Russia produce a similar-looking lace. Cluny Lace always has geometric patterns and lots of braided bars. Bedfordshire Lace is very similar, but it has beautiful floral designs and twining foliage. Value $35-55.

CHANTILLY LACE STYLE

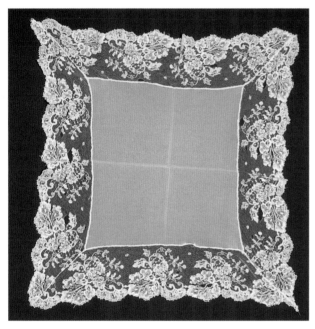

A fine Chantilly Lace trim with a shadow effect in the design and a hexagonal ground. The lace can appear to use two different sizes of netting because of the thread wraps. It always has a fine patterned edge that looks like miniature apostrophes. The designs vary from very fine, medium, or heavy in silk, cotton, or rayon thread. The most familiar Chantilly Laces are black and are found in Spanish mantillas, shawls, and vintage fans. Value $10-25.

EMBROIDERED NET LACE STYLE

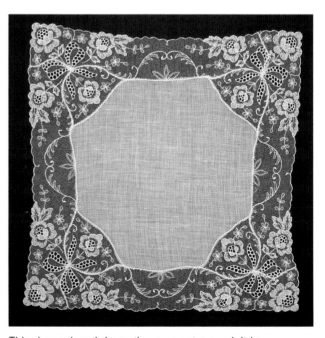

This shows thread decoration on a net ground. It has a structured, yet loose, hand-sewn appearance. These are often called wedding hankies, because they are white and very feminine. Value $20-35.

DUCHESSE LACE STYLE

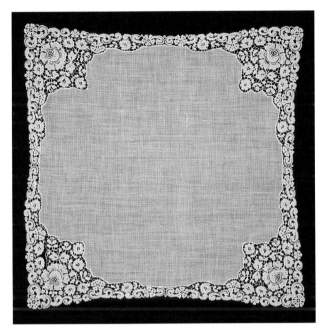

This Chemical Lace is a version of Duchesse Lace with no net ground and lots of scrollwork, flowers, and leaves. Fancy fills and the variation of multiple layers of stitches give the lace a shaded appearance. The decorations can appear to be created in separate groups that are joined together with thread bars. Value $10-20.

FLANDERS LACE STYLE

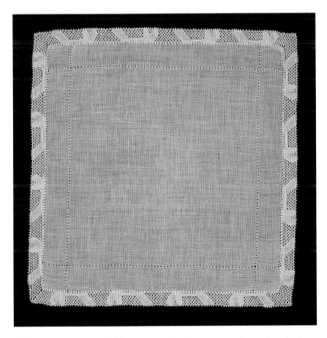

This is a sturdy, reliable, and plain lace made from five-hole mesh with small and simple geometric shapes. Value $5-15.

HAIRPIN BORDER LACE STYLE

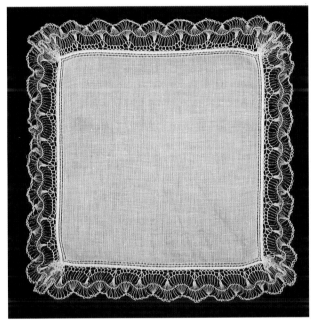

This lace-making technique is produced with a crochet hook and threads that are knotted around either a old fashioned hairpin, small knitting needles, or a two-prong fork. It is considered an inexpensive lace, and the loose hairpin-knot work was often joined in rows by traditional crochet stitches. Value $15-25.

LEVERS LACE STYLE

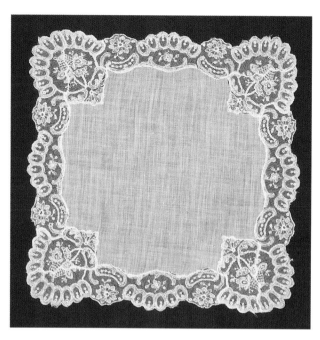

This machine-made lace was produced by twisting thousands of individual threads to replicate Pillow Lace patterns. It is intricate and delicate looking. Value $20-35.

LIMERICK LACE STYLE

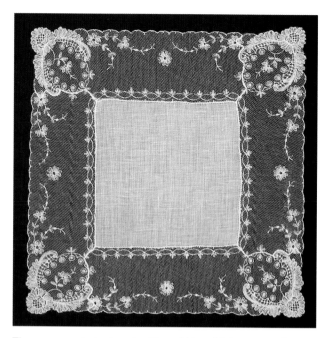

There appear to be two families of Limerick Lace: one from Ireland and one from England. This hankie is English, and shows the basic features of simple outlined florals with some fills of long needle-run stitches. These hankies can have a mechanical look, because their designs closely follow the mesh direction and sometimes use longer and looser stitches. Value $10-25.

LILLE LACE STYLE

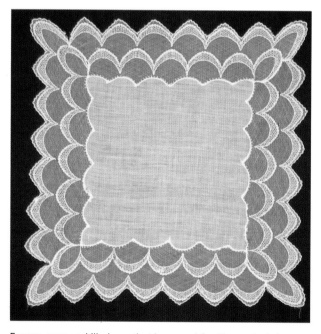

France gave us Lille Lace that is named for it's mesh; it is now called "point ground mesh." This mesh is tiny and made from two twisted linen threads. Ornamentation is simple and delicate, so it compliments the graceful mesh. Some Lille Lace designs have small square dots as subtle and sparingly applied background elements. Value $20-35.

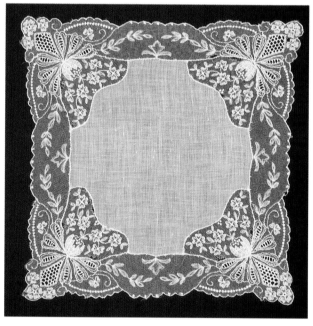

This is Irish Limerick Lace that often has shamrock designs present. Outline threads can be chain stitched with very elaborate flourishes of flowers and complex fills. Value $20-35.

MALINE SHEER LACE STYLE

This extremely fine net has no decorations to obstruct it's own beauty. It was used folded double, and sewn as a border on hankies. As can be seen here, it was available in more colors than white. Value $20-35.

NANDUTI LACE STYLE

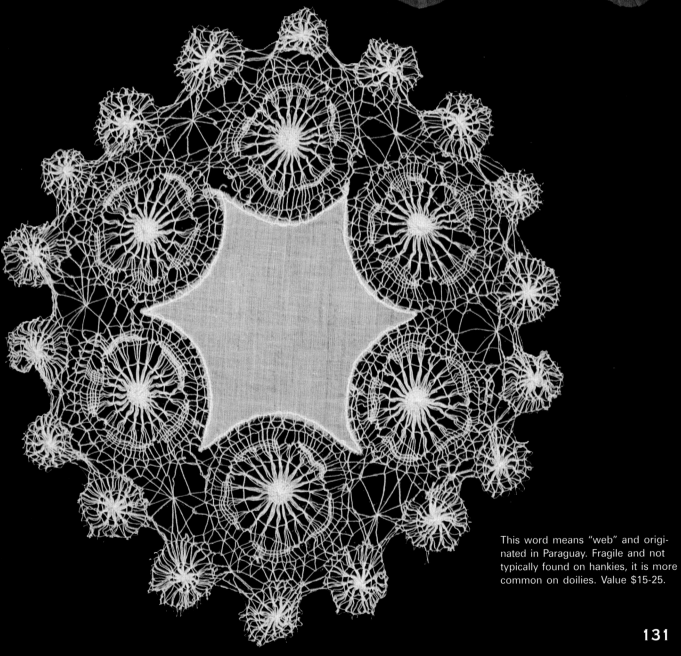

This word means "web" and originated in Paraguay. Fragile and not typically found on hankies, it is more common on doilies. Value $15-25.

NORMANDY LACE STYLE

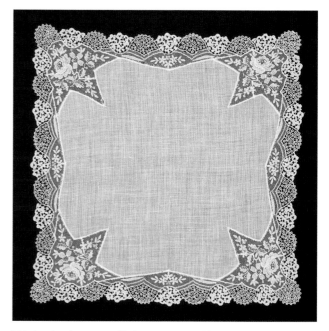

This is a hanky crazy quilt that was created by sewing different varieties of lace scraps onto one piece. It is decorative and notable in style because it combines net lace with needlework lace and some tatting. Lace hanky crazy quilts often have beautiful inserts and medallions, as this example does. Value $20-35.

NEEDLEWORK LACE STYLE

This lace is elaborately hand-sewn with geometric designs of multiple threads arranged in wandering rivers of stitches. Hankies can be found with this lace in several different thread colors used on the same piece. This style has not been found in any catalogs. They are very special hankies. Value $10-20.

POINT VENICE LACE STYLE

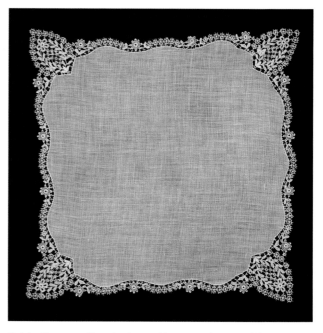

Originally a needlepoint lace, this example resembles Venetian Lace, slightly raised lace is called Venice. If the lace had more variety of stitch heights it could be called Grospoint. There is also a combination called Grospoint Venice. Value $10-20.

ROSALINE LACE STYLE

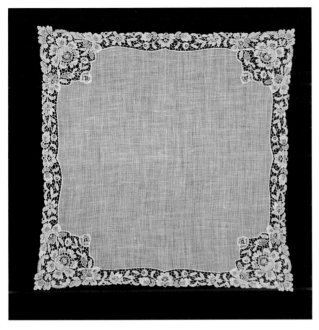

This lace has tendrils and trails of leaves and flowers. The decorations are filled with small holes and the centers of the flowers have distinct round sewn circles. Value $20-30.

TAMBOUR LACE STYLE

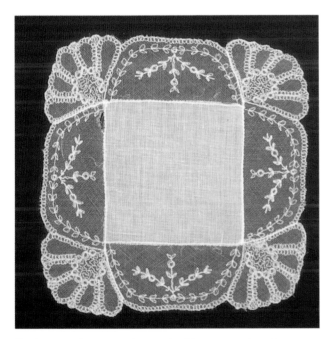

Tambour hooks are used to embroider coarse thread over a net ground to create flowers and leaves. Then, finer thread is embroidered inside the outline in different fill designs. Some of the net holes are stretched or enlarged to accentuate the lace designs.

TENERIFE LACE STYLE

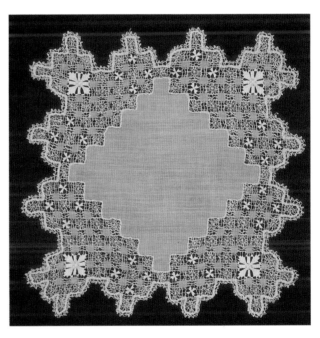

This style is spelled many ways. This is the cadillac of drawn work because it is so delicate and intricate;.a real treasure. Value $35-55.

ST. GALL LACE STYLE

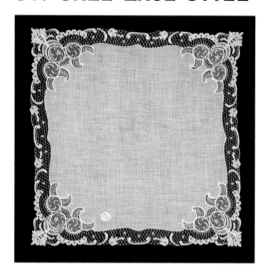

This lace resembles Venice Lace, but it is woven firmer and can be found with designs from very simple to very elaborate. Value $10-25.

SPARKLIES!

Additions were made to some lace hankies. Sequins and tiny pearls and rhinestone studded lace handkerchiefs appeared in 1951 and were very popular. Value $10-25.

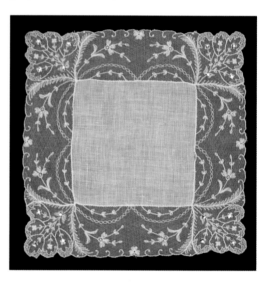

VENETIAN LACE STYLE

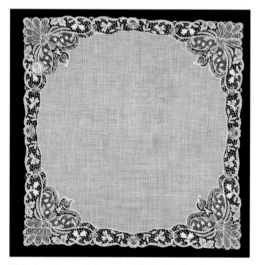

This lace is reminiscent of Point Venice Lace, as many laces are. Value $20-35.

VALENCIA LACE STYLE

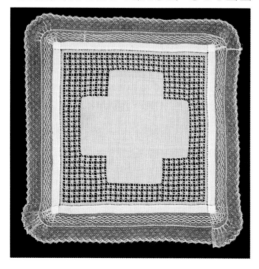

Valenciennes lace, with diamond- or round-shaped small netting as a background, was extremely popular for trims on hankies. The lace is always finished with a picot and is never made wide. This white wedding hankie has two rows of soft Valencia Lace trim. The center of this hankie shows the drawn work style called "Japanese work." It has tiny drawn work squares that cover a large area. Japanese work is always very delicate and fragile. Value $20-45.

LACE GALLERY IDENTIFICATION SURVEY

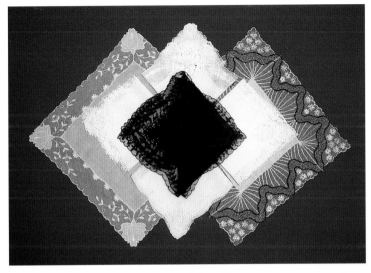

Now it is your turn to identify some lace styles and decoration techniques on four hankies! Remember, there can be combinations. The answers are shown at the bottom of this page, but don't peek!

1.

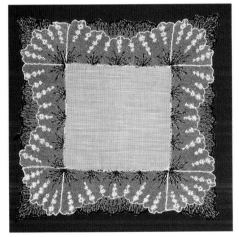

3.

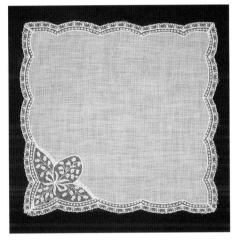

2.

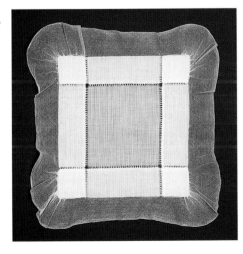

4.

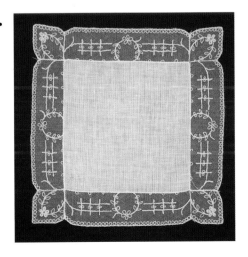

No peeking at the answers ahead, please!

1. Two colors of Needlework Lace

2. Maline Sheer Lace style trim on a Drawnwork technique hankie

3. Brocade Band Lace style trim, with corner insert of Appliqué Lace technique on net

4. Limerick Lace style

APRON GALLERY

A soft yellow, organdy fabric apron with one hankie cut into sections to decorate the small pocket and add a subtle accent to the hemline. Value $10-20.

Housewives of the 1950s entertained at home. She could create special hankie aprons for tea and coffee get-togethers, breakfast with the family, church dinners, and holidays. The drape of hankie aprons are complimentary to a lady's natural shape. Hankie aprons vary in size from a Mary Tyler Moore tiny to an Opie Taylor's Aunt Bee robust. These aprons were not sold in stores, so where did they come from? Have you ever seen a pattern for a hankie apron?

HANKIE CHIT-CHAT

To answer these questions, collectors were asked to share any stories they had about old hankies. Judy White responded:

Do any of you remember making handkerchief aprons in 7th grade? They were made with two extra big, flowered handkerchiefs, the kind the waitresses on TV are always shown with hanging out of their pocket for decoration on shows like Happy Days, American Graffiti, *etc. Anyhow, we took one hankie and turned it on point. Then we split the other hankie up the center and sewed the diagonal edges to the top corners of the one on point. The waist band and ties—all one piece of course—were made with grosgrain ribbon. And then we gave them to our mothers for Mother's Day. That would have been in 1954-55 in Missouri. Actually, they were kind of pretty.*

The hankie apron style Judy described is called the Floral Wings design. As she said, they were Home Economics class creations, so can be found with a variety of sewing quality. You can almost see a schoolgirl gritting her teeth and trying very hard to sew a straight seam before deciding to take Mechanical Drawing or a Foreign Language class next semester, anything but sewing! Of course, there were the State Fair adolescent achievers who made perfect pleats and creative finishing touches. Following are hankie aprons made by students and homemakers during the 1950s.

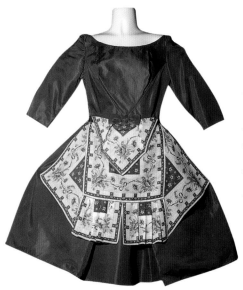

A favorite hankie apron because it has an elaborate waistline treatment and ample width to protect the fullest skirts. It has pretty blue satin ribbon ties. Value $15-25.

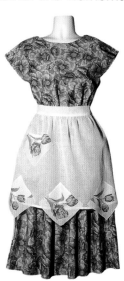

A Swiss dot fabric apron with hankies cut into four sections. Three of the sections are set on point around the hemline to create a scalloped border. The fourth section decorates the apron's pocket. Value $10-20.

FLORAL WINGS

The Floral Wings design aprons are found with waistbands and ties made from grosgrain ribbon, satin ribbon, and the more sturdy strips of additional hankies. The ruffle treatments are usually pleated or simply gathered. Most Floral Wing hankie aprons do not have pockets.

With a shiny satin waistband and ties, softly gathered edging, and a small meandering floral border, this apron looks huggable. Value $10-20.

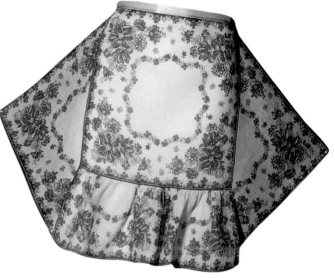

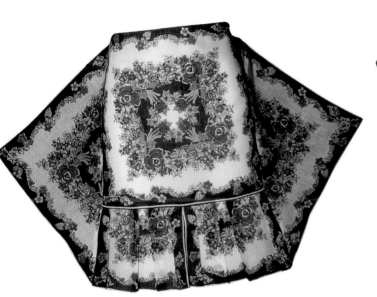

Hankies with colorful, radiating, floral designs that guide your eye directly to the center panel of this apron. The tie-backs are made from matching hankie strips. Value $15-25.

Very few floral hankies are found with orange as the outstanding color, so this hankie apron was an unusual find. Value $10-20.

Entirely constructed from hankies, this apron is framed by tumbling baskets of flowers with bows. Value $15-25.

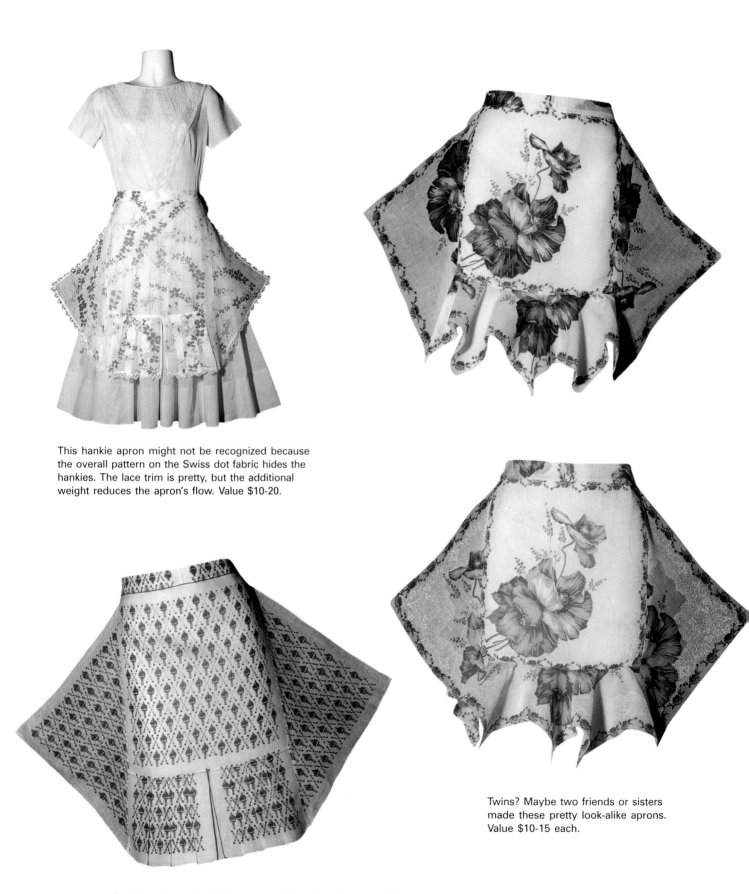

This hankie apron might not be recognized because the overall pattern on the Swiss dot fabric hides the hankies. The lace trim is pretty, but the additional weight reduces the apron's flow. Value $10-20.

Twins? Maybe two friends or sisters made these pretty look-alike aprons. Value $10-15 each.

Gentlemen's hankerchiefs were used to make this apron. The printed pattern looks like Olympic torches. Value $10-20.

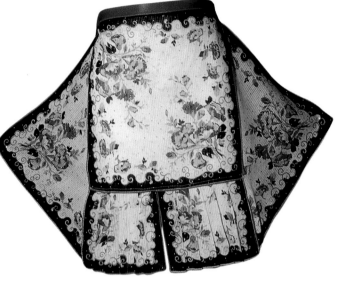

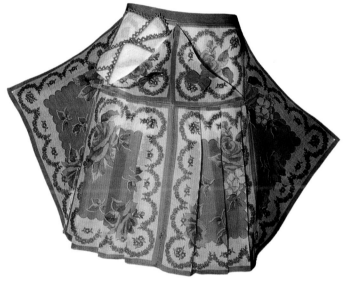

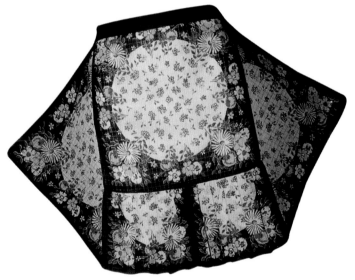

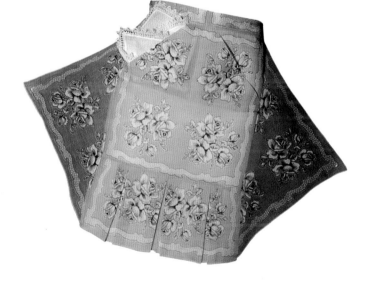

These two aprons were made from hankies woven with an interesting thread manipulation that creates a geometric pattern in the cloth. This effect is visually pleasing and the printed floral designs make these desirable hankie aprons. Value $15-25 each.

It takes an experienced seamstress to create perfectly matched pockets from folded hankies. These are two lovely examples, demonstrating good sewing skills and creativity, made from five hankies, instead of the standard three. Value $15-25 each.

I'VE GOT SOMETHING IN MY POCKET

The wearer of this hankie apron style could put a Sherman Tank in her pocket, it is soooo big! Lovely, but not functional, the full-size pocket can hold everything you might want to take on a trip to Europe. The only restriction to it's load-bearing ability is the support capability of the organdy fabric itself. Almost every hankie apron made in this style has thread damage to the fabric, due to overloading the mammoth pocket. Value $5-10 each.

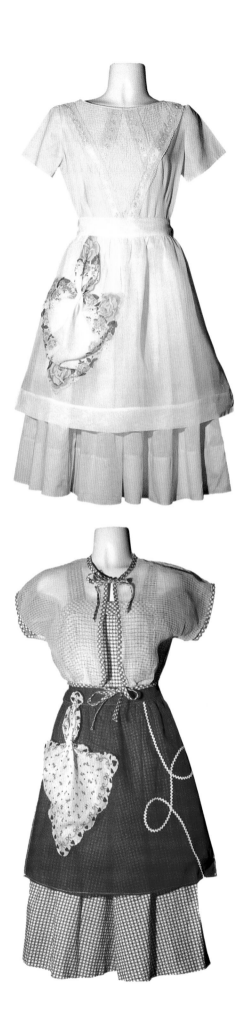

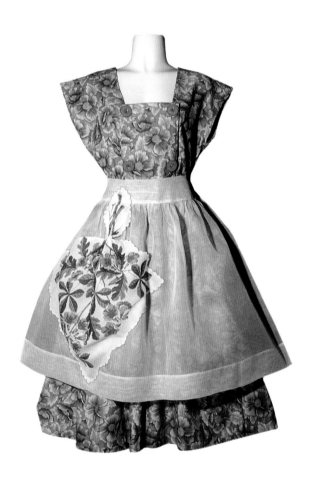

HEAVENLY VISITATIONS

The weightless and translucent character of organdy fabric makes these hankie aprons look like Cinderella gowns for the kitchen. The background colors were commonly white, but pale pink, pale green, pale blue, and other pastels can also be found. Almost always present is one small right-hand pocket made from another hankie or matching organdy fabric. Value $10-20 each.

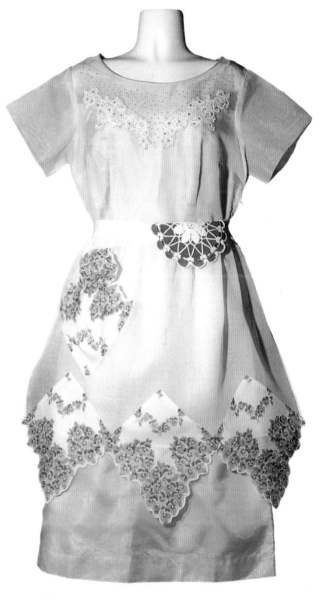

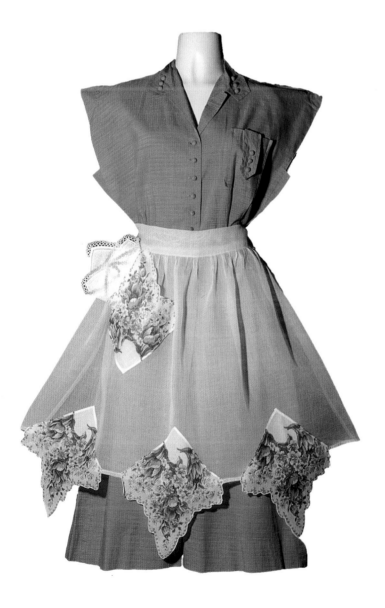

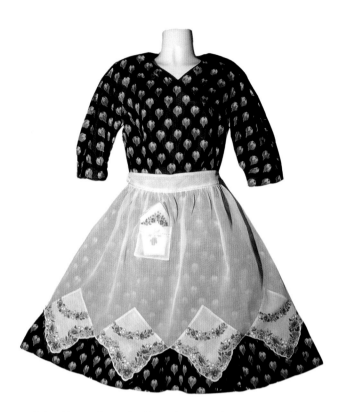

A hankie can be tucked into the organdy pocket to add a complimentary peek-a-boo effect. Value $15-25.

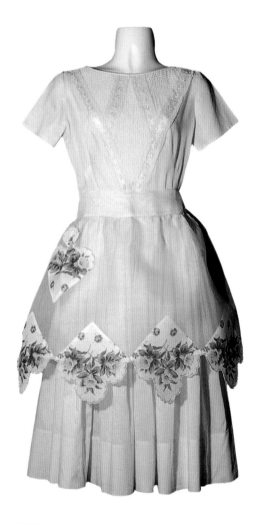

A magazine ad offering a hankie apron pattern.

FABRIC GALLERY

WHAT KIND OF FABRIC IS THIS HANKIE?

Once you have read this chapter, you will be an "Honorary Official Best Guess Hankie Fabric Identification Expert." There are chemical and burn tests that can be preformed on fabrics to determine the fiber types, but we do not want to damage the hankies by using them. Better to give your best guess and follow *Clothes with Character,* a book developed for health classes, by Hazel Thompson Craig and originally published in 1941. She suggested unraveling a piece of the fabric yarn and looking at it under a microscope. Today, you can use your computer and scanner. Hazel wrote that cotton fiber looks like a piece of twisted ribbon. Linen fiber looks like a section of bamboo cane. Wool fiber looks like a scaly stem. Silk fiber resembles an imperfect glass rod. Rayon fiber resembles a more perfect glass rod.

These hankie fabrics are magnified 400%.

Top Row: samples of plain woven cotton hankies. Notice how the threads relax slightly between the woven intersections.

Second Row: on the far left is higher quality textured cotton which retains a smoother-looking thread between woven intersections. The center picture shows sheer cotton which has finer threads with a widely spaced weave. Printing on this fabric gives the illusion of two different thread weights. On the far right is fabric made from cactus fibers that have a shiny appearance and appear knitted, rather than woven.

Bottom Row, on the far left, linen threads are strong, glisten a little, and retain a crisp look and straight grid pattern. The center picture shows silk threads that glisten and can be identified by merely touching the fabric. On the far right is Abaca fabric with threads that maintain their positions well. There can be a slight glisten to the fabric that appears to be knitted, rather than woven.

NATURAL FABRICS

Cotton and linen fabrics are woven from harvested natural materials. These are the major fabrics used to make hankies. They are durable and absorbent, and they launder well. Cotton hankies seldom will be found with their original labels still attached, because they have been used. If a label is present, it will seldom identify the cloth. Linen hankies are quite proud of their heritage and "Pure Linen" or "Irish Linen" is often printed on the label that identifies the maker. Sometimes the hankie will have one label with the maker's name and an additional "Pure Linen Hand-Rolled" label.

COTTON FABRIC HANKIE EXAMPLES

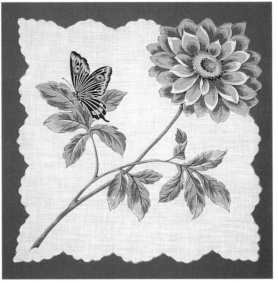

Butterfly and blossom printed on a cotton hankie, circa 1950s. Value $5-10.

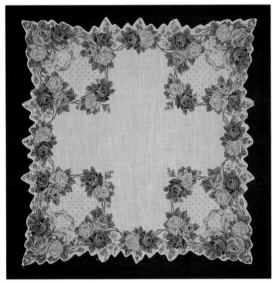

Two large cotton hankies, with big scalloped machine hems, are similar to some offered in *Montgomery Ward*, 1950s, catalogs. Value $5-10 each.

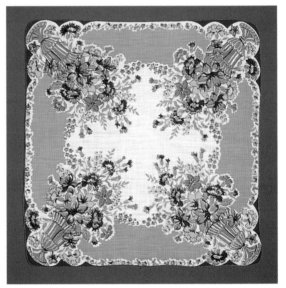

Vases filled with flowers decorate each corner of this cotton, machine-hemmed hankie. The design came in various color combinations circa 1940s. Value $5-10.

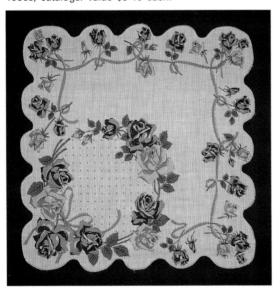

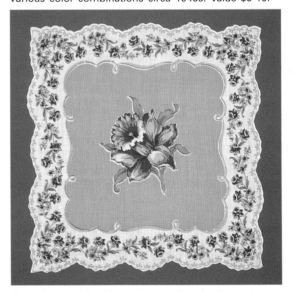

A small cotton hankie, with a scalloped edge and tightly machine-stitched hem, that came in four colors with flowers, circa 1940s. Value $5-10.

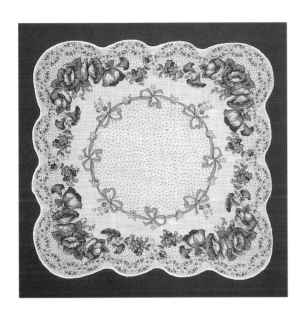

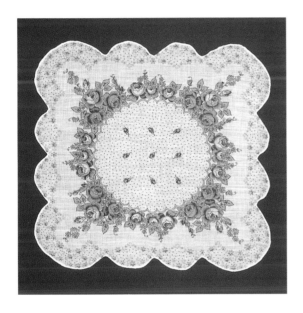

Three hankie designs offered in a variety of color combinations. These cotton hankies can be found with rolled or tightly machine-stitched hems. Perhaps the rolled hem hankies are older, or there was a change in method during their production. Value $5-10 each.

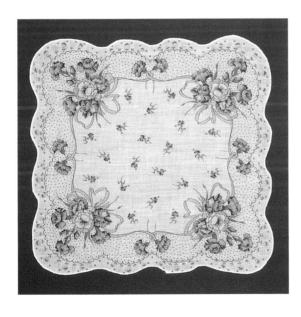

Three cotton hankies with interesting corner treatments. This style can be found made from cotton or linen. These have different hem treatments. The pink bouquet hankie has a tightly machine-stitched hem all around. The blue hankie has a combination of a flat-fold, machine-stitched hem and a hand-rolled hem around the large blossom in the corner. The brown hankie has a rolled hem all around, circa late 1940s. Value $10-20 each.

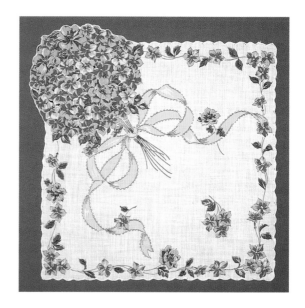

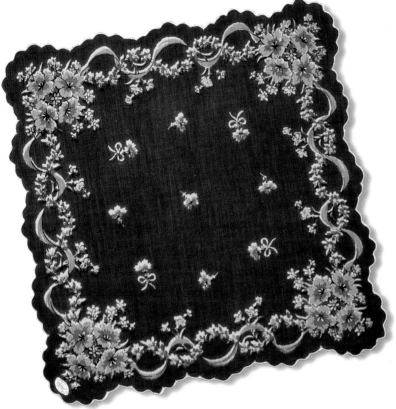

A brown, cotton, Burmel hankie with a scalloped, machine-stitched hem. Value $5-10.

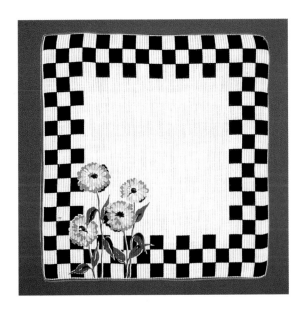

Three cotton hankies with woven textured fabric and flat machine hems. The checkerboard hankie and the red blossom hankie both have flat-folded, straight-machine-stitched hems. The last hankie, with the woven grid design fabric, has an unusual border hem. The hankie's edge is encased with a white fabric binding, circa 1940s. Value $5-10 each.

Two sheer cotton, printed hankies. The first is printed with a bicycle-built-for-two. The second has peaceful farm scenes in each corner. Value $10-20 each.

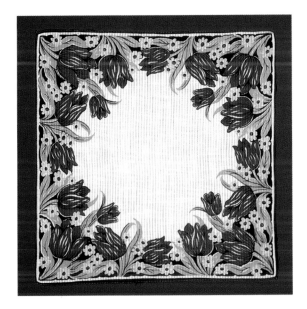

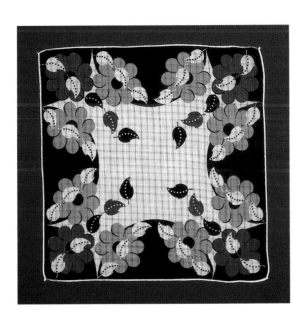

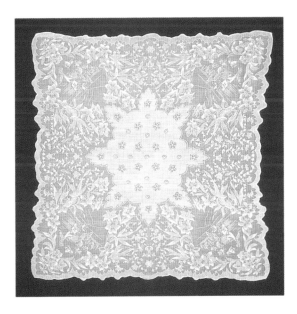

SILK FABRIC HANKIE EXAMPLES

Silk fabric makes the most luxurious hankies. Gathered threads, provided by hard working little silk worms, are woven into elegant fabric. Silk possesses a superior dyeing ability and was the fabric of choice for many vintage commemorative hankies.

Two silk commemorative hankies. One is from the 1933 Worlds Fair in Chicago. Value $10-15.

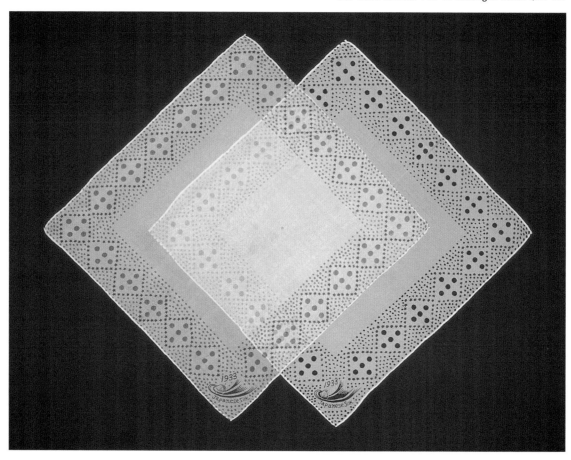

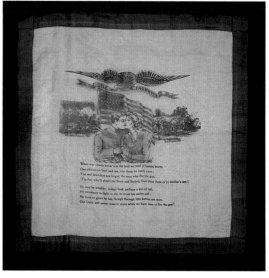

The second is from the World War One era. According to two older women, the United States government sent these hankies as condolence to wives who lost their husbands in the war. Value $25-35.

LINEN FABRIC HANKIE EXAMPLES

The Herrmann Handkerchief Company made wonderful children's theme hankies and irresistible ladies' linen hankies. Their hankies with the metallic label intact are seldom found. The two shown here are elegant Irish linen and have perfectly rolled hems, circa late 1940s. Value $15-25 each.

The Hamilton Handkerchief Company made linen hankies in this shape and style. Their products were outstanding, circa 1940s. Value $10-20.

149

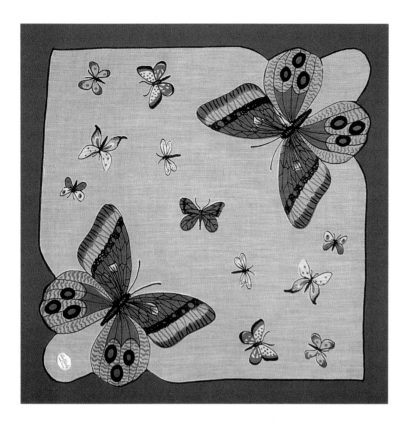

Carol Stanley pure linen hand rolled hankies were made in the Philippines. Stanley hankies seem to bridge the styles between Kimball and Burmel in their designs. Their quality is superior, designs are tasteful, and these hankies were both employed and collected. Value $10-20.

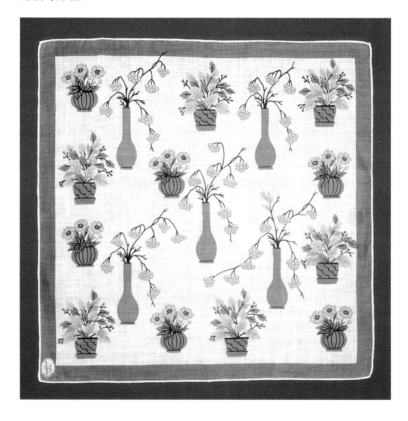

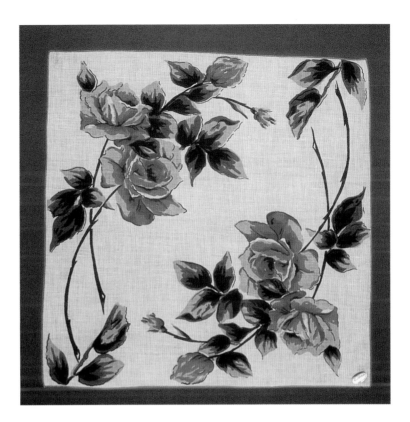

Two Best Seller linen hankies. circa
1940s. Value $5-10 each.

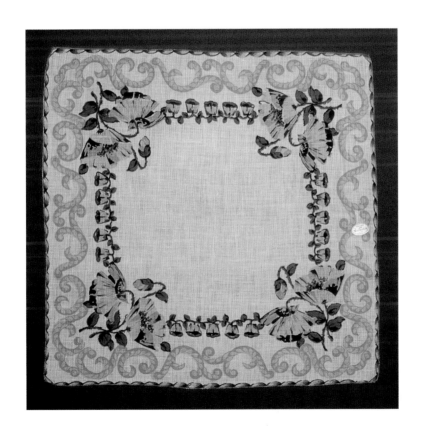

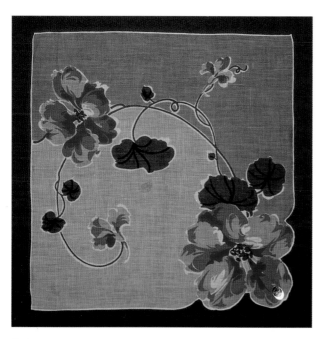

Seldom are Glamour Girl labels found. These linen hankies have a distinctive style. When clean, value $10-15.

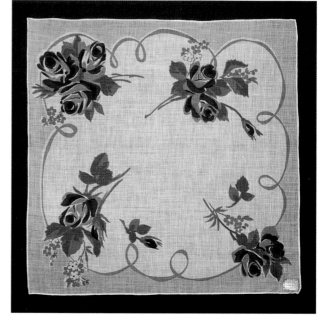

Kimball linen hankies are readily available. They were made to be used and enjoyed, circa 1940s. Value $5-10 each.

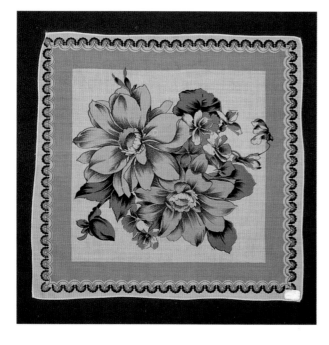

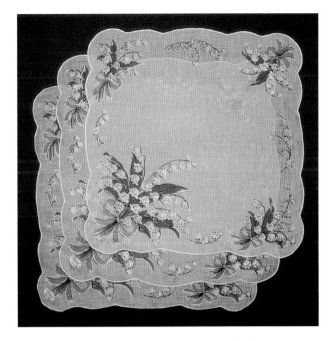

Burmel linen hankies could probably form a line from here to the moon. So many pretty offerings, consistent in quality and creative designs, the group of three is from the 1940s. Value $5-10 each.

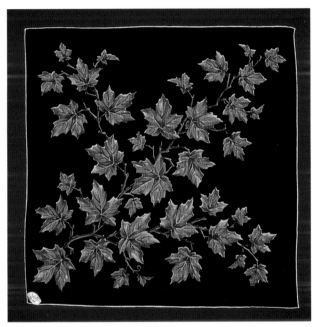

The two large Burmel hankies are from the 1950s. Value $10-20 each.

Novelty Fabrics

Other natural materials are pina, pineapple fiber, cactus fiber, and banana fiber. They made interesting knitted-looking, shiny hankies. They are made from cellulose fibers grown in Costa Rica, Guatemala, Honduras, and Panama. The cactus fabric is made from century plant fibers. All of these fabrics have been used to make hankies for tourists to those regions. Another member of this group is Abaca, which is also called Manila hemp. It offers a heavier texture and can have a glossy shine. In the Philippines, the Abaca is combined with pina or pineapple fibers and woven into fine fabrics.

Novelty Fabric Examples

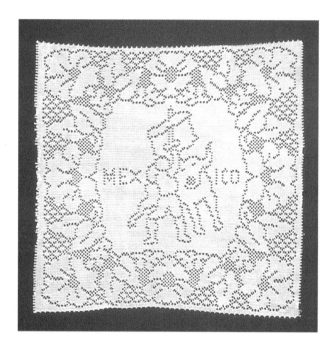

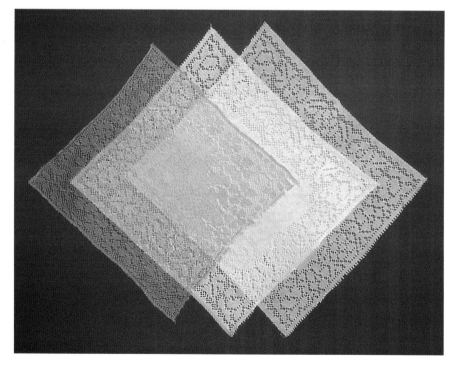

Novelty fabrics were perfect for travel memorabilia. These could be printed, but the images didn't look clear because to the fabric is course and stretches. Images were added to the fabric by manipulating the threads into dot-to-dot patterns. Value $5-10 each.

Nylon yarns were perfected by the DuPont Company in 1938 and used exclusively for military items until after World War II. Created from the combination of carbon, hydrogen, nitrogen, and oxygen, nylon makes an abrasive and resistant fabric. It was used to make hankies and dresses in the late 1940s. Although nylon did not make good useful hankies, they were used effectively as an accessory to dress-up a pocket or tie onto a girl's ponytail. Some of the prettiest nylon hankies have flocking to add texture and dimension. They are the hardest things to iron, because the fibers refuse to cooperate and form a flat surface; they prefer waves. If the iron is too hot, poof!, a big empty burn hole appears where there use to be a flocked nylon flower. Nylon makes better car tires and bulletproof vests than hankies.

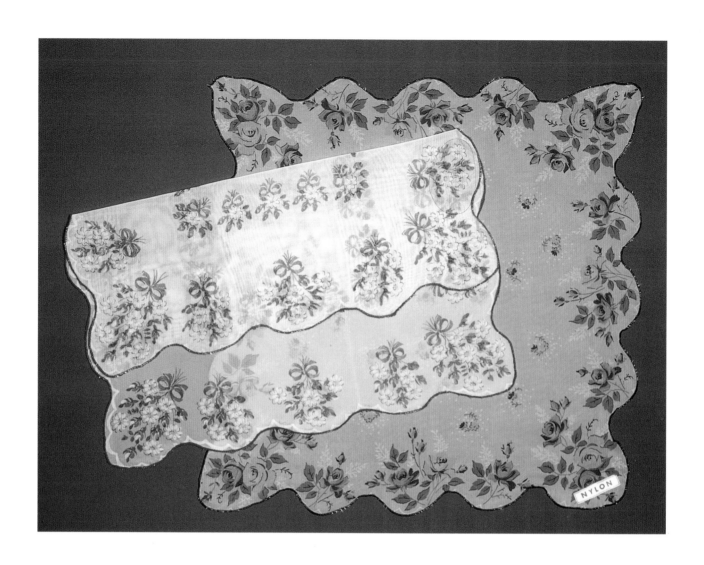

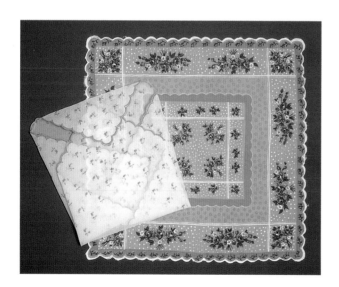

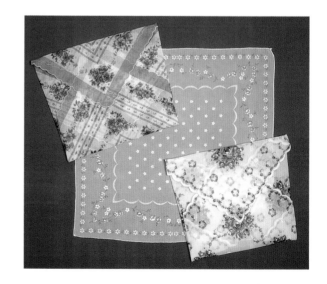

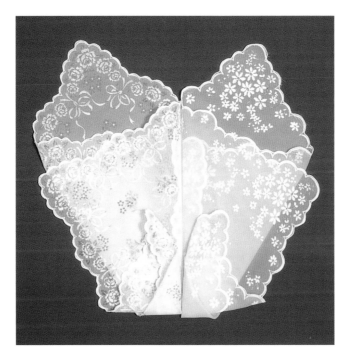

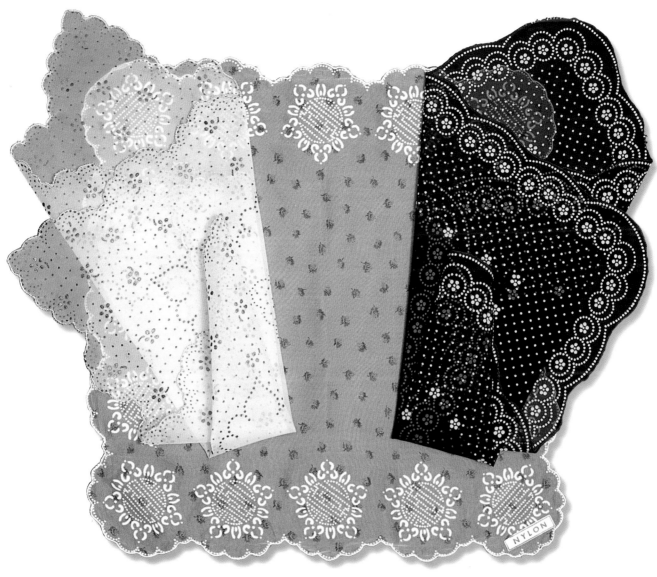

RESOURCES

Braum-Ronsdorf, Margaret. *The History of the Handkerchief.* Leigh-on-Sea, England: Publishers by appointment to the late Queen Mar, 1967.

Caplin, Jessie F. *The Lace Book.* New York: The Macmillan Company, 1932.

Collins, Herbert Ridgeway. *Threads of History: Americana Recorded on Cloth 1775 to the Present.* Washington: Smithsonian Institution, 1979. A superior collection of commemorative handkerchiefs covering American military, political, and social events.

Cook, Cathy. "Hankie Pankie," *Collectibles Flea Market Finds.* Spring, 1998.

Erb, Phoebe Ann. *Floral Designs from Traditional Printed Handkerchiefs.* Owings Mill, Maryland: The Stemmer House International Design Library®, 1998. This book contains wonderful black-and-white line art of floral design handkerchiefs and interesting historical information.

Florence, Judy M. *Aprons of the mid-20th century: To Serve and Protect.* Atglen, Pennsylvania: Schiffer Publishing Ltd., 2001.

Harding, Deborah. *Crafting with Flea Market Fabrics.* Pleasantville, New York: Readers Digest Association, 1998. Outstanding handicraft project pictures and instructions.

Hoge, Sr., Cecil C. *The First Hundred Years are the Toughest: What We Can Learn from the Century of Competition between Sears and Wards.* Berkeley, California: Ten Speed Press, 1988.

Industry Committee No. 46 for the Handkerchief Manufacturing Industry and the Prohibition, Restriction or Regulation of Home Work in the Industry. "Home Work in the Handkerchief Manufacturing Industry." *Publication No. 11270.* Washington, D. C.: United States Government. September 5, 1942.

Kiplinger, Joan. Index of her written articles on vintage textiles. Fabrics.net Spokane, Washington. http://www.fabrics.net/joan.asp

Kurella, Elizabeth. *The Complete Guide to Vintage Textiles.* , Iola, Wisconsin: Krause Publications, 1999. This is a must have book written by an expert vintage textile researcher. She also has a detailed web site on lace at www.lacefairy.com

Lebhar, Godfrey M. *Chain Stores in America 1859-1950.* New York: Chain Store Publishing Corp., 1959.

May, Florence Lewis. *Hispanic Lace and Lace Making.* New York: Printed by order of the Trustees New York 1936. May was a corresponding member of The Hispanic Society of America. Contains 432 illustrations of Hispanic laces and lace makers.

McNair, Malcolm P. and May, Eleanor G. *The American Department Store 1920-1960: A Performance Analysis Based on the Harvard Reports.* Boston, Massachusetts: Harvard University, Bureau of Business Research, Bulletin No. 166.

Mihalick, Roseanna. *Collecting Handkerchiefs.* Atglen, Pennsylvania: Schiffer Publishing Ltd., 2000. I wore out my copy of this book. It is absolutely necessary to have it in your personal hankie library.

Murphy, J.J., *Children's Handkerchiefs: A Two Hundred Year History.* Atglen, Pennsylvania: Schiffer Publishing, Ltd. ,1998.

Newman, Sharon L. *Handkerchief Quilts.* San Marcos, California: American School of Needlework® Inc., 1992.

Schwab. David E. *The Story of Lace and Embroidery and Handkerchiefs.* New York: Fairchild Publications Inc, 1957. Detailed listing of lace terms with descriptions, pictures, and interesting machine lace production information.

Warner, Pamela. *Embroidery A History.* London: B.T. Batsford Ltd., 1991. Great pictures and information on needle-made and imitation laces.

INDEX